S0-BBZ-449

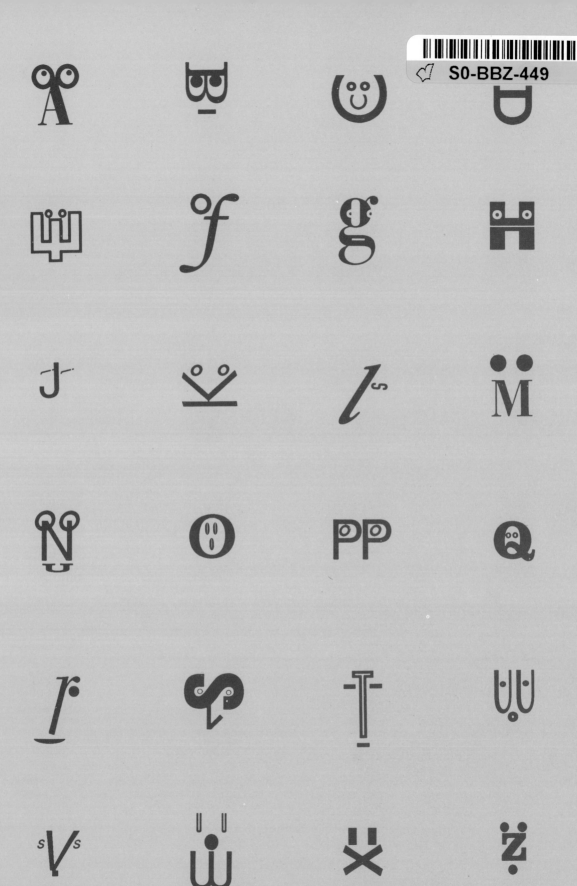

TYPE FACES

DESIGNED & EDITED BY

GERRY ROSENTSWIEG

PUBLISHED BY

MADISON SQUARE PRESS

Copyright © 1995 by Madison Square Press
 All rights reserved. Copyright under International and
 Pan-American Copyright Conventions.

No part of this book may be reproduced, stored in a
 retrieval system or transmitted in any form, or by any
 means, electronic, mechanical, photocopying, recording or
 otherwise, without prior permission of the publishers.

While Madison Square Press makes every effort possible to
 publish full and correct credits for each work included in this
 volume, sometimes errors of omission or commission may
 occur. For this we are most regretful, but hereby must
 disclaim any liability.

This book is printed in four-color process, a few of the designs
 reproduced here may appear to be slightly different than in their
 original reproduction.

ISBN 0-942604-46- 6
 Library of Congress Catalog Card Number 93-079606 TK

Distributors to the trade in the United States and Canada:
 Van Nostrand Reinhold 115 Fifth Avenue, NY 10003

Distributed throughout the rest of the world by:
 Hearst Books International
 1350 Avenue of the Americas New York, NY 10019

Published by:
 Madison Square Press
 10 East 23rd Street, New York, NY 10010

TYPE*faces*
 Editor: Gerry Rosentswieg
 Designer: Gerry Rosentswieg/The Graphics Studio

PRINTED IN HONG KONG

CONTENTS

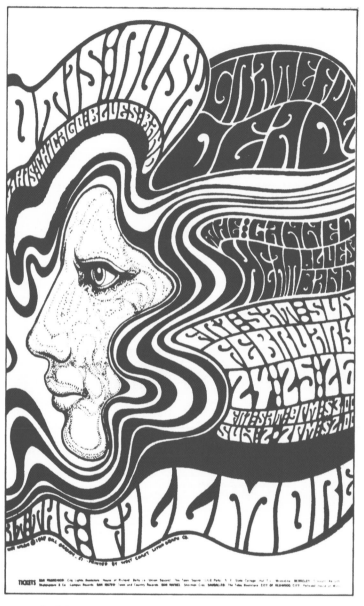

Psychedelic poster, 1967,
designed by Wes Wilson;
produced as an advertisement
for an Otis Rush/Grateful
Dead concert. The Art
Nouveau-style type, becomes
the hair of this TYPE*face*.

INTRODUCTION

Since recorded history began, man has used his own image to placate his God, insure fertility and provide successful hunting. Early cave paintings, sculptures and ceramics show man as hunter, craftsman and the center of the world. Every age has recorded its own life and left its ideas and values for succeeding generations. In each era the face has been used as a personal mark, on signet rings, on heiroglyphics and on coffin decorations, as a way of communicating personality and identity and of leaving a mark for the future. As early as the middle of the 18th century, faces made of typography have been noted; I call these TYPE*faces*. The

industrial revolution, while replacing a crafts tradition of hundreds of years, did create a prosperous middle-class ready to celebrate the successes of industrial mass production. As products became more readily available, the need to distinguish one product from another became a necessity. A face, easily recognizable and identifiable, especially to a largely illiterate population, made a good, strong symbol of a product, service or place. Early brand marks such as "Turks Head" tobacco products and "Pharoah" brand rope, used a face to make it's brand memorable. Towards the end of the century, these TYPE*faces* become more

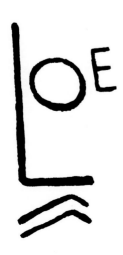

prevalent, the monograms on this page are by artists of the Vienna Secession, circa 1896. The marks represent, from the top - Adolph Bohm, Oscar Schimkowitz and Berthold Loess and demonstrate the harmony of proportion, and clarity of form that characterized this art movement. These forms, TYPE*faces*, soon became logos as companies sought more lasting identification, and discovered how

useful they could be. Every art movement from the late 19th century used this device. As early as the beginning of the century, cattlebrands utilized the TYPE*face* device. Designed to reflect personal names or features of the cattle ranch, they represent a colorful pictorial language that expresses typical western humor and wit. The brands shown are 1- Seven-Up Bar, 2- Double R Cross Half Circle, 3- Owl 4- OTO Bar. 5- Sitting Heart Lazy B and 6- Half Circle Three O. These brands are typically American and might be the basis for the TYPE*face* tradition in the United States. Brands consist of letters, numeral s, characters or symbols, or a combination of one or more of these elements. This also might be a good definition of the TYPE*face*. Some of the most distinguished designers and fine artists have used this device on personal marks as well as on posters, since the poster form was invented. TYPE*faces* often are humorous, sometimes elegant and have been created in almost every country, every language and every type of alphabet from the Roman to the Arabic, Cyrillic and Oriental. Some TYPE*faces* are inadvertent, the artist or designer had something else in mind, but the results are TYPE*faces*. The figure at right is from an alphabet designed by Herman Zapf for use on the Arabic newspaper, Alahram. It was not designed as a TYPE*face*, yet it has an unmistakable face-like quality. These inadvertent faces are

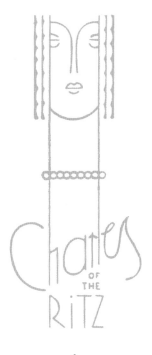

the exception rather than the rule. Almost all the examples shown were meant to be faces. Some of the most creative TYPE*faces* were produced in the years between the World Wars. The label for Charles of the Ritz is a wonderful example of an Art Deco TYPE*face*. Designed in 1933 by Marcel Lecoque, it was used for beauty products and perfume packaging. The neck of this face is an integral part of the lettering, the "H" and "L". In another example from this period, the Made In France symbol, designed in 1921 by Maurice Alexander, has all the best features of the Art Deco period, the absence of superfluous details, the dynamic sense of composition and the use of Cubist inspired geometric shapes. The symbol, which has been translated for use in English speaking countries, was originally "Fait en France," and I suspect the "A" shapes that defines the face were originally "F"s. Following this period, imaginative work was done in Switzerland and the United States. The catalog cover shown at left, designed by Max Bill in 1944 for the museum exhibit "Concrete Art," shows the influence of the Bauhaus and the Swiss "Zurich Group." They advocated a strict visual discipline and the use of modular grids. The piece shown is marginally a TYPE*face,* the copy block becomes the eyes and nose, the location of the exhibit and the date become the mouth. The TYPE*faces* in

konkrete kunst

10 einzelwerke ausländischer künstler aus basler sammlungen
20 ausgewählte grafische blätter
30 fotos nach werken ausländischer künstler
10 œuvre-gruppen von arp
 bill
 bodmer
 kandinsky
 klee
 leuppi
 lohse
 mondrian
 taeuber-arp
 vantongerloo

kunsthalle basel 18. märz - 16. april 1944

this book are primarily from the 20th century, there are some notable exceptions, all duly annotated. The earliest example is probably a face drawn into a Sumerian tablet, circa 2800 B.C. Basic pictograms became cuneiform writing, which turned into heiroglyphics, which became demotic writing, which in turn became Greek letters. The TYPE*face* tradition began almost 5,000 years ago. Of course, it was abandoned for about 4,800 years, to be picked up by the graphic design profession as a favored method for giving personality and individuality to communication messages. The styles and forms that TYPE*faces* take seem to be almost limitless, and the variety of intended meanings seem equally limitless.

Logo designed in 1958 for Spiral Press, United States. Designed by Joseph Blumenthal, this mark has a primitive almost Maori quality that was a part of this publisher's ouevre. As a TYPE*face* it is made up of three "S" shapes, the final curlicue, tail, becomes eyes and mouth.

TYPE*faces* as editorial icons are used on posters, book jackets, record albums, announcements and ads. This device brings a memorable wit as well as a unique characterization to editorial material.

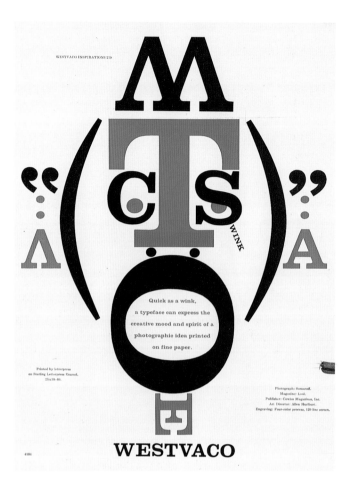

WESTVACO INSPIRATIONS 210

Quick as a wink,
a typeface can express the
creative mood and spirit of a
photographic idea printed
on fine paper.

Printed by letterpress
on Sterling Letterpress Enamel.
25 x 38-80.

Photograph: Somoroff.
Magazine: Look.
Publisher: Cowles Magazines, Inc.
Art Director: Allen Hurlburt.
Engraving: Four-color process, 120 line screen.

4181

WESTVACO

12.1

12.1
**Designer: Bradbury Thompson
1958 U.S.
Client: Westvaco Corporation
illustration from *Westvaco
Inspirations #210*.**
"Quick as a wink..." This
TYPE*face* was inspired by a
six-year-old child's painting
with her first printed words
in its large mouth. The
letter "s" provides a winking
eye in this playful mask
which spells out the
client's name.
Principle Type: Clarendon Bold

13.1
**Designer: Fred Woodward
AD: Jennifer Goland
1984 U.S.
Client: Confetti Magazine
illustration**
This TYPE*face* was part of
an editorial challenge to
explore a new approach to
type design using the head-
line "Bold Face."
Principle Type: Helvetica Bold

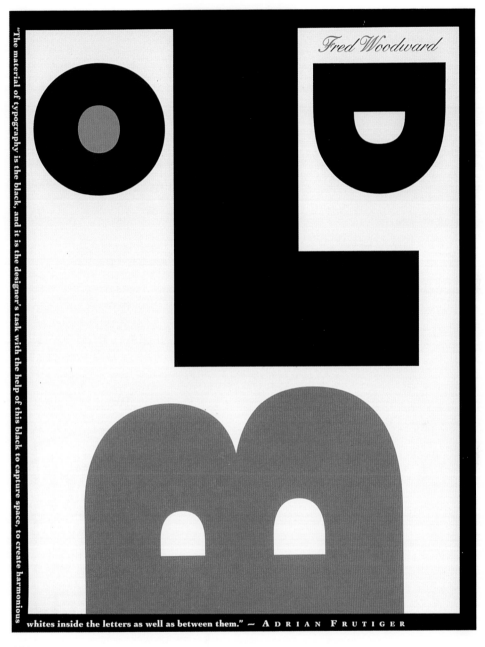

Fred Woodward

"The material of typography is the black, and it is the designer's task with the help of this black to capture space, to create harmonious whites inside the letters as well as between them." ~ ADRIAN FRUTIGER

13.1

14.1

Designer: Thomas H . Geismar
AD: Jim Cross, Cross Associates
1985 U.S.
Client: Simpson Paper
 Poster for the series *Connections*.
 The connection is made graphically,
 the word "Robotic" becomes a robot face.
 The simple shapes enclosing the
 illustration are not really necessary.
Principle Type: Futura, Kabel and Raleigh

14.2

Designers: Beckley and Morris
1932 Great Britain
Client: Robot Yeast Merchants
Logotype.
 This logo is a classic typeface. The robot
 face is the spiritual predecessor
 of the Simpson poster above.
Principle Type: Handlettered

15.1

Designer: Neville Brody
1983 Great Britain
Client: Rock Group, Out
 Poster
 The broken-down quality of the
 xeroxed type gives a primitive
 excitement and vigor to this mask-
 like typeface.
Principle Type: Computer generated

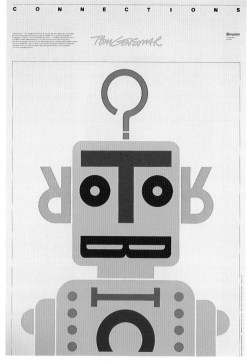

14.1

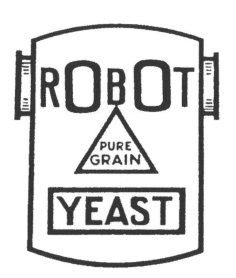

14.2

THE LEGENDARY

OUT +

O

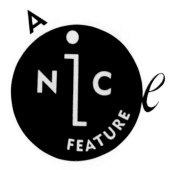

16.1

16.1
Designer: Alexander Isley
St: Alexander Isley Design
1988 U.S.
Client: Spy Magazine
 Article Masthead for *A Nice Feature*
 This story slug for Spy Magazine is
 typically irreverent. The "A" becomes a
 clown hat, the "e" becomes an ear.
Principle Type: Metro Black

16.2
Designer: Takenobu Igarashi
1990 Japan
Client: Tama Art University
 ***Funny Face* Poster**
 This poster designed on the Mac is a
 straightforward TYPE*face*.
Principle Type: Helvetica, Garamond &
Computer generated

17.1
Designer: Paula Scher, Pentagram
1987 U.S.
Client: School of Visual Arts
 Poster
 This TYPE*face*, created as an art school
 promotion combines elements from
 two modern art movements: the layout
 borrowed from an Alexei Jawlensky
 modernist painting and the typography
 used in the Russian constructivist manner.
Principle Type: Eagle Bold and Futura

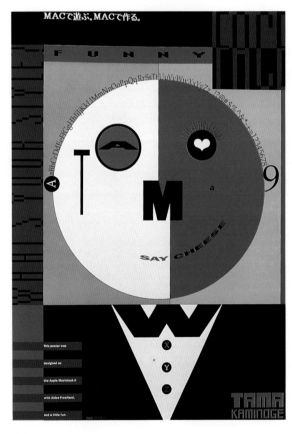

16.2

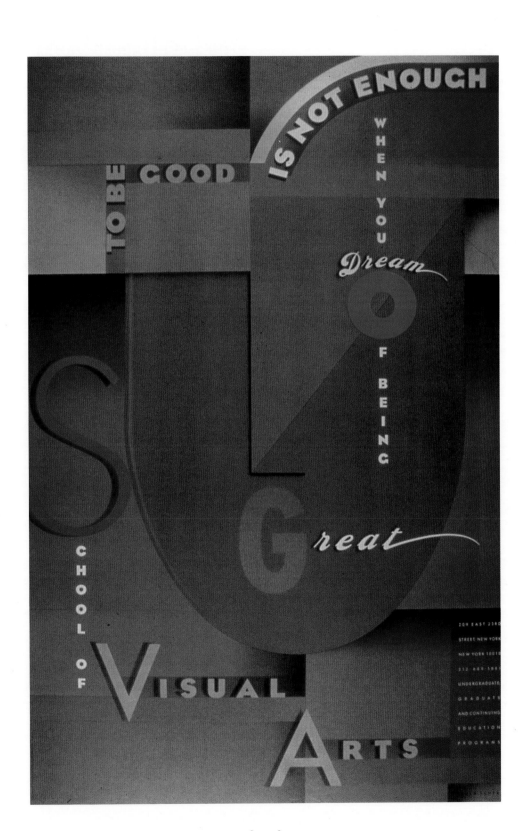

18.1
Designer: Seymour Chwast
1990 U.S.
Client: Warner Books
 Book Jacket for _The Left-Handed_
 Dictionary
 This TYPE*face* illustration uses various
 styles and sizes of type to create an
 illustration for this book of quotes.
Principle Type: Various

18.2
Designer: Scott Taylor
AD: Joe Molloy
1991 U.S.
Client: Graduate Management
Admission Council
 Editorial Illustration for _Selections,_
 The Magazine of the Graduate
 Management Admission Council
 TYPE*face* illustration for the article, *Cognitive*
 Science Perspectives on Problem Solving.
Principle Type: Various Dingbats
and Special Characters

19.1
Designer: Milton Glaser
1978 U.S.
Client: Museum of Modern Art, New York
 Poster
 This TYPE*face*, created for a show entitled
 Dada and Surrealism, was rejected. The
 poster appeared in a paper promotion for
 Neenah paper called *Ten Razzberries*.
Principle Type: Hand-Lettered

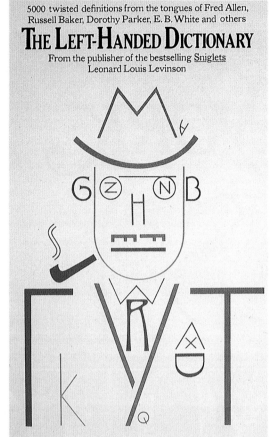

18.1

18.2

MOMA LIKES TO SEE YOU

19.1

20.1

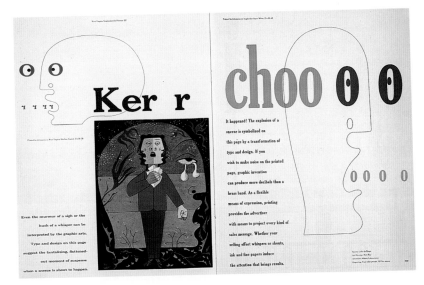

20.2

20.3

20.1
Designer: Gerry Rosentswieg
1986 U.S.
Client: usr group
 Book Cover for *The Unix Directory*
 This TYPE*face* illustration uses modified letterforms suggesting a literal interface.
Principle Type: Univers XB Condensed

20.2
Designer: Tor Hinnerud
1954 Sweden
Client: Cederroths Tekniska Fabrik
 Poster for Samarin Fruit Salts
 TYPE*face* illustration which the "p" becomes both eye and nose.
Principle Type: Standard Family

20.3
Designer: Bradbury Thompson
1949 U.S.
Client: Westvaco Corporation
 Interior spread from *Westvaco Inspirations*, #177
 This type illustration captures the moment when a sneeze occurs. The TYPE*face* is only an adjunct to the playful idea that transforms the image into a sneeze, seen and heard.
Principle Type: Clarendon Family

21.1
Designer: Bob Burns
Ag: Burns, Connacher and Waldron
Design Associates
1987 U.S.
 Self Promotion
 This illustration,"EyeQ" is a visual pun. The face is completed with a mouth made of the two lines of the studio name.
Principle Type: Bernhard Modern

21.2
Designer: Ernie Smith
1971 U.S.
Client: Public Broadcasting Service
 Logo
 This TYPE*face* alters one edge and displaces the negative space to bring a human quality to these distinctive initials.
Principle Type: Handlettered

21.1

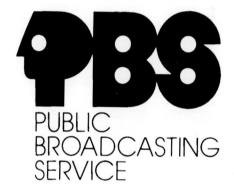

21.2

LOOKOUT

22.1

22.1

Designer: Dick Danne

1982 U.S.

Client: *Lookout*

Masthead

This rather abstract TYPE*face* for a proposed political and consumer activism magazine illustrates itself, almost two faces, "oo" and a winking "ou"

Principle Type: Manhattan Black, Modified

22.2

Designer: E. McKnight Kauffer

1952 U.S.

Client: Random House

Book Jacket for James Joyce *Ulysses*

TYPE*face* illustration. The "U" becomes an eye and the elongated "L" a nose, the author's name is a crooked mouth, apt for this stream of consciousness novel that creates and distorts words.

Principle Type: Futura Ultra, Modified

23.1

Designer: Seymour Chwast

AD: Robert Anthony

1986 U.S.

Client: Society of Illustrators

Humor Show Call For Entries

This composite type illustration is more drawing than type, but the "O" walrus is a true TYPE*face*.

Principle Type: LoType

23.2

Designer: Paul Rand

1987 U.S.

Client: AIGA Communication Show

Call For Entries

This 13-letter word with each letter designed by a well-known designer has a "U" TYPE*face* made from 7 letters, "U"s of course.

Principle Type: Helvetica Family

22.2

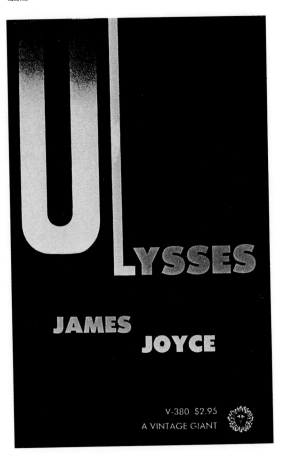

U LYSSES

JAMES JOYCE

V-380 $2.95
A VINTAGE GIANT

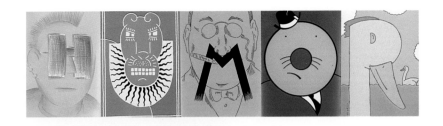

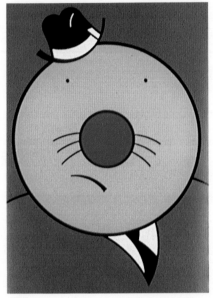

23.1

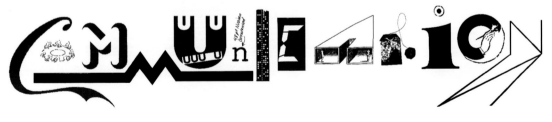

23.2

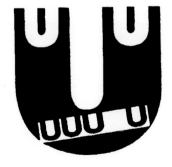

24.1
Designer: Milton Glaser
AD: Cy Nelson
1970 U.S.
Client: E.P. Dutton
 Paperback Book Cover
 A pen and ink drawing is the background for this typeface. The idea for the type treatment came from the fact that the poet's name always appeared in lower case.
Principle Type: Bodoni

25.1
Designer: Alan Peckolick
1975 U.S.
Client: Random House
 Book Jacket for *Beards*
 While not strictly a TYPE*face*, the figurative typography becomes the book title.
Principle Type: Handlettered

25.2
Designer: Katsuichi Ito
AD: Ellen Shapiro
1988 Japan
Client: Robondo Publishers
 Illustration from *The Image of Kanji*
 Reprinted in *U&lc*
 Tongue-in-cheek rendering of the kanji "kiku," which means "listen to." The characters with some earphone additions is a listening TYPE*face*.
Principle Type: Handlettered

25.3 25.4
Designer: Akihiko Tsukamoto
1991 Japan
Client: Exam
 The body copy in these ads make beards on these TYPE*faces*.
Principle Type: Kategana

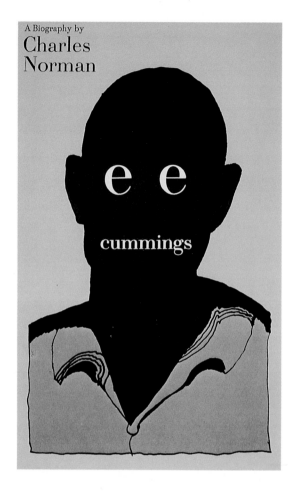

24.1

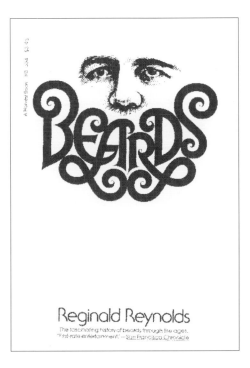

25.1

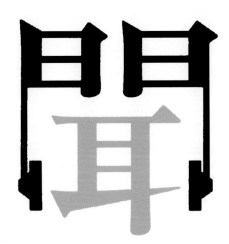

25.2

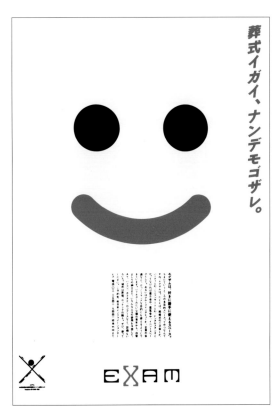

25.3/25.4

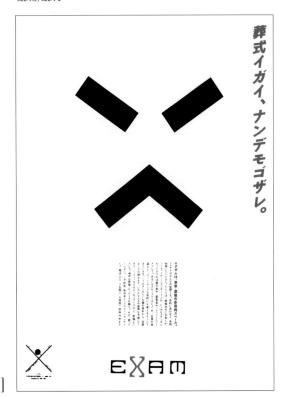

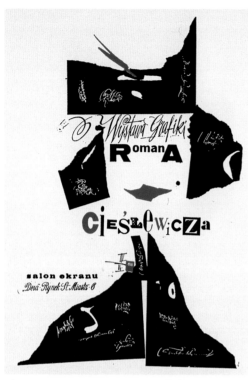

26.1

26.1
Designer: Roman Cieslewics
1961 Poland
Client: Salon Ekranu
Poster
For an exhibit of graphic art, the word
RomanA become the eyes for this
stylish poster.
Principle Type: Various

27.1
Designer: Peter Mertens
1989 Holland
Client: Typ/Typografisch Papier
Magazine Cover
A typographical journal of controversial
ideas. The "Y" becomes nose, mouth and
throat, while the diacritical mark (umlaut)
become the eyes.
Principle Type: Handlettered

27.2
Designer: Roman Weyl
1962 Germany
Client: Volksbuhne Theatre of Berlin
Poster
This play about money and ethics
pictures a "fat cat" character whose
mustache and beard spell out the title
and author's name.
Principle Type: Handlettered

27.3
Designer: Milton Glaser
1987 U.S.
Client: World Health Organization
The "W" becomes a death head and a
double heart in this TYPE*face* logo, *AIDS:
A Worldwide Effort Will Stop It.*
Principle Type: Handlettered

27.4
Designer: Antonio Fronzoni
1961 Italy
Client: Grandi Magazzini Cavellini
This small space ad utilizes type to
draw the TYPE*face*.
Principle Type: Standard Family

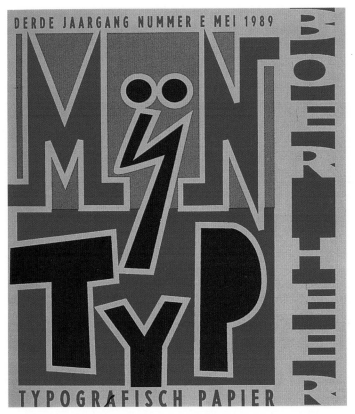

27.1

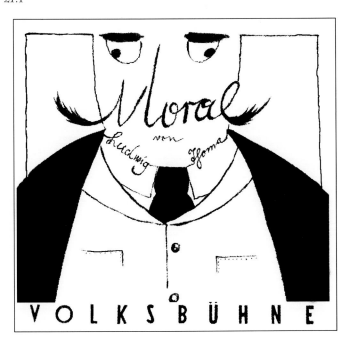

27.2

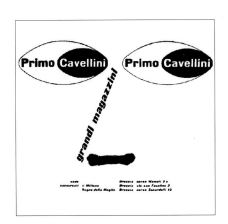

27.3

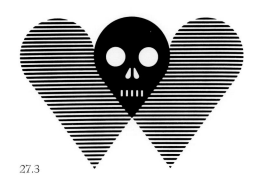

27.4

THE SHOCK IS GONE

BY STEVEN HELLER

THE SHOCK IS GONE

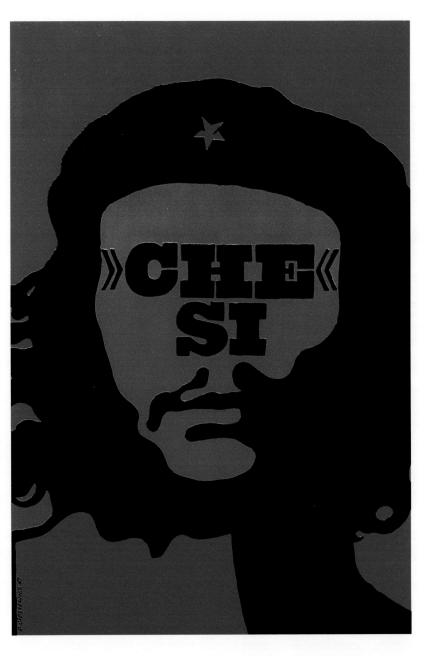

Designer: Tibor Kalman/M&Co.
1987 U.S.
Client; ID Magazine
 Page Layout
 Illustrating an article that
 suggests typographic design
 has lost its ability to shock.
 This simple TYPE*face* uses
 the body copy to create a
 face shape and curved type-
 lines to make the sad/happy
 face graphics.
Principle Type: Futura

29.1
Designer: Roman Cieslewics
1967 Poland
Client; Opus International
 Poster
 This abstract portrait of
 Che Guevara is by definition
 a TYPE*face*. The type of the
 headline becomes the features
 in this popular agitprop poster.
Principle Type: Helvetica

29.1

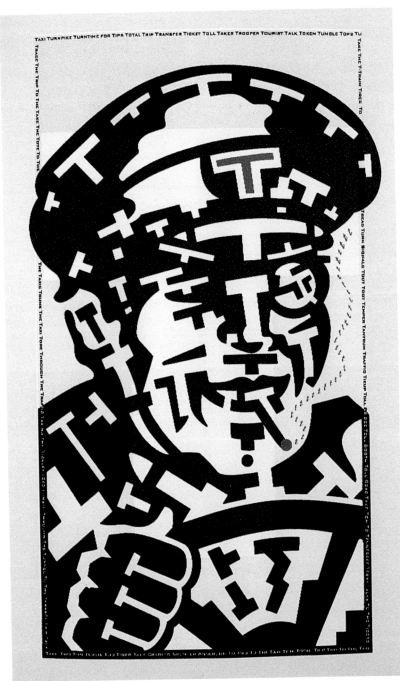

30.1

30.1

Designer:
Charles Spencer Anderson
1989 U.S.
Client: American Center
for Design
 Page Layout
 ZYX: 26 Poetic Portraits
 is a witty and sophisticated
 alphabet book .The letter "T"
 becomes the unit of design
 for this taxi driver TYPE*face.*
Principle Type: Handlettered

31.1
Designer: Mick Csaky
1986 Great Britain
Client: Theo Crosby's 60th
Birthday Tribute/Pentagram
 Mask illustration
 The computer drawing
 TYPE*face* becomes a mask to
 add to Crosby's collection.
Principle Type: Courier

31.2
Designer: Andrew Watt
1986 Great Britain
Client: Interset
 Advertisement
 This TYPE*face* design, using
 Hamlet's dialogue to create the
 author's face is a popular de-
 vice for computer drawings
Principle Type: Helvetica

31.3
Designer: Christine Hershey
1987 U.S.
Client: Creative Type
 Logo
 The type design of this
 TYPE*face* becomes a vaguely
 Mona Lisa-ish portrait
 and a unique identity.
Principle Type: Helvetica

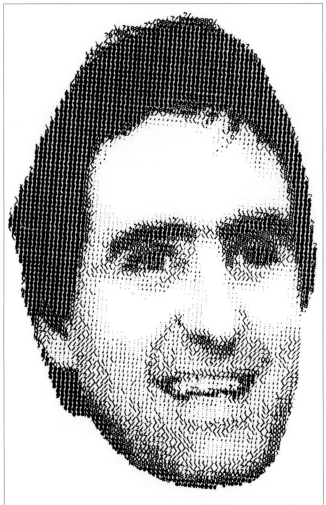

31.1

To be, or not to be, that is the question. Whether 'tis nobler in the mind to suffer the slings and arrows of outrageous fortune, or to take arms against a sea of troubles and by opposing end them. To die—to sleep, no more; and by a sleep to say we end the heart-ache and the thousand natural shocks that flesh is heir to. 'tis a consummation devoutly to be wish'd. To die, to sleep. To sleep, perchance to dream—ay, there's the rub: for in that sleep of death what dreams may come, when we have shuffled off this mortal coil, must give us pause—there's the respect that makes calamity of so long life. For who would bear the whips and scorns of time, th'oppressor's wrong, the proud man's contumely, the pangs of dispriz'd love, the law's delay, the insolence of office, and the spurns that patient merit of th'unworthy takes, when he himself might his quietus make with a bare bodkin? Who would fardels bear, to grunt and sweat under a weary life, but that the dread of something after death, the undiscover'd country, from whose bourn no traveller returns, puzzles the will, and makes us rather bear those ills we have than to fly to others that we know not of? Thus conscience does make cowards of us all, and thus the native hue of resolution is sicklied o'er with the pale cast of thought, and enterprises of great pitch and moment with this regard their currents turn awry and lose the name of action. Soft you now, the fair Ophelia! Nymph, in thy orisons be all my sins remember'd. (Oph.) Good my lord, how does your honour for this many a day? (Ham.) I humbly thank you, well. (Oph.) My lord, I have remembrances of yours that I have longed long to redeliver. I pray you now receive them. (Ham.) No, not I, I never gave you aught. (Oph.) My honour'd lord, you know right well you did, and with them words of so sweet breath compos'd as made the things more rich. Their perfume lost, take these again, for to the noble mind rich gifts wax poor when givers prove unkind. There, my lord. (Ham.) Ha, ha! Are you honest? (Oph.) My lord? (Ham.) Are you fair? (Oph.) What means your lordship? (Ham.) That if you be honest and fair, your honesty should admit no discourse to your beauty. (Oph.) Could beauty, my lord, have better commerce than with honesty? (Ham.) Ay, truly, for the power of beauty will sooner transform honesty from what it is to a bawd than the force of honesty can translate beauty into his likeness. This was sometime a paradox, but now the time gives it proof. I did love you once. (Oph.) Indeed, my lord, you made me believe so. (Ham.) You should not have believed me; for virtue cannot so inoculate our old stock but we shall relish of it. I loved you not. (Oph.) I was the more deceived. (Ham.) Get thee to a nunnery. Why wouldst thou be a breeder of sinners? I am myself indifferent honest, but yet I could accuse me of such things that it were better my mother had not borne me. I am very proud, revengeful, ambitious, with more offences at my beck than I have thoughts to put them in, imagination to give them shape, or time to act them in. What should such fellows as I do crawling between earth and heaven? We are arrant knaves all, believe none of us. Go thy ways to a nunnery. Where's your father? (Oph.) At home, my lord. (Ham.) Let the doors be shut upon him, that he may play the fool nowhere but in's own house. Farewell. (Oph.) O help him, you sweet heavens. (Ham.) If thou dost marry, I'll give thee this plague for thy dowry: be thou as chaste as ice, as pure as snow, thou shalt not escape calumny. Get thee to a nunnery, farewell. Or if thou wilt needs marry, marry a fool, for wise men know well enough what monsters you make of them. To a nunnery, go—and quickly too. Farewell. (Oph.) Heavenly powers, restore him. (Ham.) I have heard of your paintings well enough. God hath given you one face and you make yourselves another. You jig and amble, and you lisp, you nick-name God's creatures, and make your wantonness your ignorance. Go to, I'll no more on't, it hath made me mad. I say we will have no mo marriage. Those that are married already—all but one—shall live, the rest shall keep as they are. To a nunnery, go. O, what a noble mind is here o'erthrown! The courtier's, soldier's, scholar's, eye, tongue, sword, th'expectancy and rose of the fair state, the glass of fashion and the mould of form, th'observ'd of all observers, quite, quite down! And I, of ladies most deject and wretched, that suck'd the honey of his music vows, now see that noble and most sovereign reason like sweet bells jangled out of tune and harsh, that unmatch'd form and feature of blown youth blasted with ecstasy. O woe is me T have seen what I have seen, see what I see.

© Andrew Watt 1986

31.2

the creative type **the creative ty**pe the creative ty
pe the creative **type the creative** type the creati
ve type the cre**a**tive type the cre**a**tive type the c
reative type th**e cr**e**a**tive type the creative t
he creative **type** thecreative **type the** creative ty
pe the cre**a**ti**ve** type the creative **type** the creati
ve type the **creative type** the creative type the cr
e**a**tive type the creative **type** the cre**a**tiv**e** type t
he cre**a**ti**ve type** the creative type the **creativ**e t
ype the cre**a**tive **type** the creative **type** the cre
ative type **the creative** type the **creative** type th
e creative **type** the creative type the creative ty
pe the cre**a**tive type the creative**type** the creati
ve type the **creative type** the cre**a**tive type the cr
e**a**tive type **the cr**e**a**tive type**the creative** type t
he creative **type** thecreative type the creative t
he cre**a**tive type **the** cre**a**tive **type the** creative t
ype the creative type **the creative type** the creat
ive type the creative type the creative type the c r
e ative type **the creative type** the creative type th
e creative type the creative type the creative typ
e the cre**a**tive type **the** creative type the creative
type the creative type the creative type the crea

31.3

32.1

Designer: Krohl Offenberg

1968 Germany

Client: City of Mainz

Poster

This TYPE*face* profile of Johannes Gutenberg set in movable type, is another example of a type portrait.

Principle Type: Franklin Gothic

32.2

Designer: George McGinnis

1970 U.S.

Client: Self Promotion

Logo

A drawn portrait that spells out the talents of the designer.

Principle Type: Handlettered

33.1

Designer: Jim Gibson

1969 Great Britain

Client: The Royal College of Art

Illustration

This profile TYPE*face* of Queen Victoria is made up of copy on the history of school.

Principle Type: New Garamond

33.2

Designer: Kit Hinrichs

AD: Harold Burch /Pentagram

1991 U.S.,

Client: Applied Graphics

Calendar Illustration

This TYPE*face* uses the first chapter of Moby Dick to create a portrait of Herman Melville

Principle Type: Handlettered

33.3

Designer: Anonymous

1994 Italy

Client: Radical Party

Advertisement

This TYPE*face* detail from a double truck newspaper ad underscores the international qualities of this organization with its use of the party name in the languages of the member countries.

Principle Type: Various

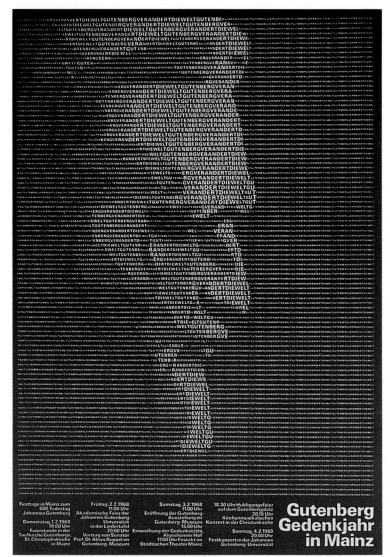

32.1

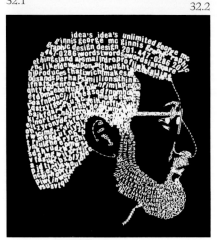

32.2

[32]

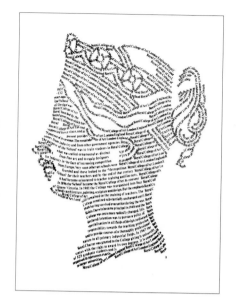

33.1

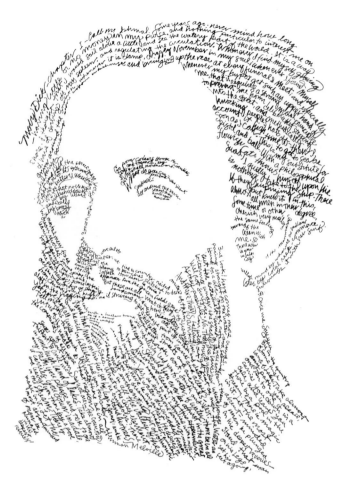

33.2

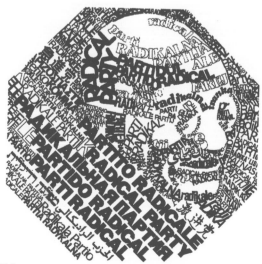

33.3

34.1
Designer: Paul Siemsen
1979 U.S.
Client: International Typeface Corp.
U&lc Cover - Put Your Best Face
Forward Competition

This TYPE*face* portrait of Picasso
is made from four sizes, weights
and variations of type.
Principle Type: ITC Koronna

The initial response to our request for graphic designs created by our readers, using only ITC typefaces, has brought us examples of work from all parts of the world. The few pieces illustrated here are of the highest caliber, and we wholeheartedly congratulate their creators and thank them for helping us to get the ball rolling (as they say in the ad game). We sincerely hope that all of the rest of you, who receive U&lc, will be inspired to jump on the bandwagon (as they also say in the ad game) and send us your work for inclusion in a future issue. Please! Only send work set with ITC faces.

Strange as it may seem, this portrait was not done by the designer of the Picasso portrait on the cover but was created by Joseph Amft, a typesetter with Scott, Foresman & Company in Glenview, Illinois. Mr. Amft says this portrait of Leo Castelli, based on a text from Men by Francesco Scavullo, derived its inspiration from the Paul Siemsen Picasso head, which he considers an extraordinary piece of typography. This work was set in four weights of ITC Korinna.

THIS ARTICLE WAS SET IN ITC BOOKMAN

35.1
Designer: Joseph Amft
1979 U.S.
Client: International Typeface Corp.
U&lc - **Put Your Best Face**
Forward Competition
This TYPE*face* portrait of Leo Castelli is made from four sizes, weights and variations of type.
Principle Type: ITC Koronna

[35]

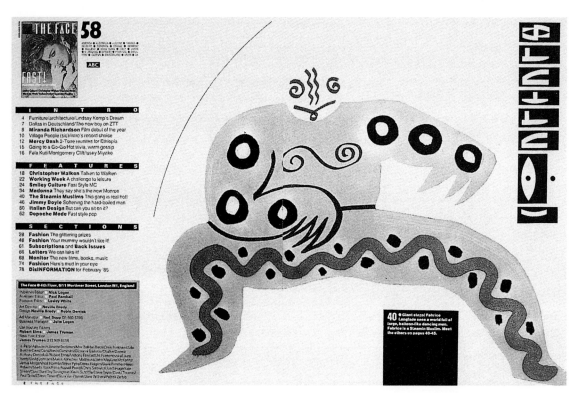

The Face @ 4th Floor, 5/11 Mortimer Street, London W1, England
Publisher/Editor **Nick Logan**
Assistant Editor **Paul Rambali**
Feature Editor **Lesley White**
Art Director **Neville Brody**
Design Manager **Robin Derrick**
Ad Manager **Rod Sopp** (51/940 5756)
Business Manager **Julie Logan**
Contributing Editors
Robert Elms James Truman
New York Editor
James Truman (212 989 4579)

40 ● Giant steps! Fabrice Langlade sees a world full of large, balloon-like dancing men. Fabrice is a Steamin Muslim. Meet the others on pages 40-45.

36.1

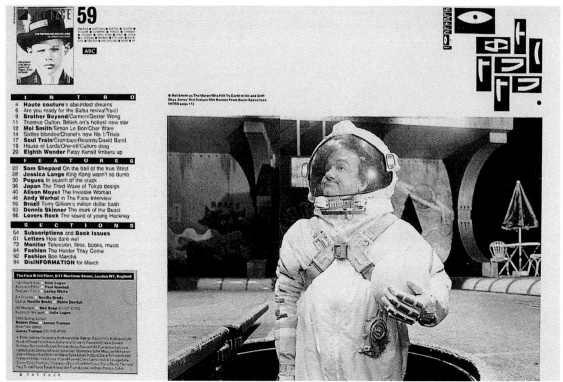

The Face @ 4th Floor, 5/11 Mortimer Street, London W1, England
Publisher/Editor **Nick Logan**
Assistant Editor **Paul Rambali**
Feature Editor **Lesley White**
Art Director **Neville Brody**
Design Manager **Robin Derrick**
Ad Manager **Rod Sopp** (01/580 8752)
Business Manager **Julie Logan**
Contributing Editors
Robert Elms James Truman
New York Editor
James Truman (212 989 4579)

● Mel Smith as The Moron Who Fell To Earth in his and Griff Rhys Jones' first feature film Morons From Outer Space (see INTRO page 11)

36.2

36.1
Designer: Neville Brody
1985 Great Britain
Client: *The Face* No. 58
Magazine Contents Page
This TYPE*face* of the word
contents was created on the
computer, with bitmapping
as part of the look. The
"C" is the mouth, and the
image is set at a right angle
to the page so that the
TYPE*face* reads even if the
word does not.
Principle Type: Computer

36.2
Designer: Neville Brody
1985 Great Britain
Client: *The Face* No. 59
Magazine Contents Page
This variation on the TYPE*face*
above, and used in the
subsequent issue no longer reads
as face or word.
Principle Type: Computer

37.1
Detail of above.

37.2
Detail of 36.1 emphasizing the
face-like quality of the first two
letters, the "C" and "O". Dots
are the eyes.

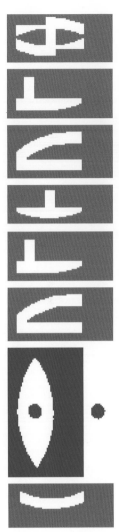

37.2

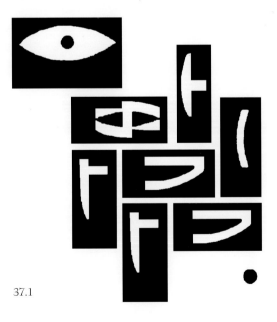

37.1

38.1
Designer: Takaaki Matsumoto
AD: Michael McGinn
1989 U.S.
Client: The JCH Group, Ltd.
 Moving Announcement
 This TYPE*face* spells out its
 message to make an interesting
 face. The "M" eyebrow and the
 script "E" are especially nice.
Principle Type: Various

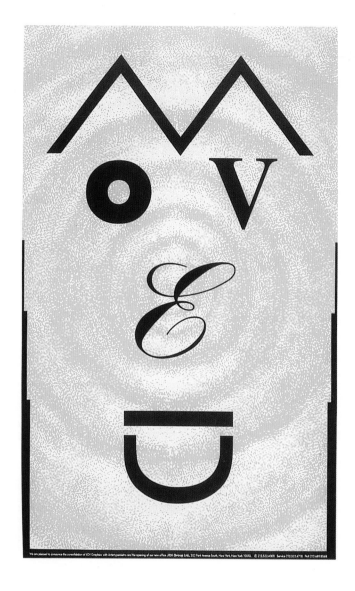

One character **TYPE***faces* - this group of icons is designed with one principle letter amplified with dots, sorts and dingbats. Since the early days of the twentieth century, these icons and logos have proven timeless, popular and memorable -

ONE CHARACTER
TYPE*faces*

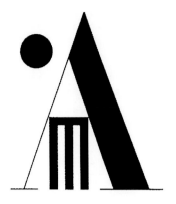

40.1

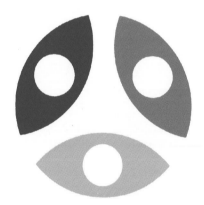

40.2

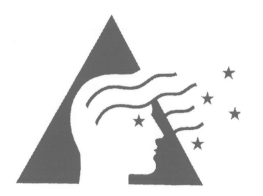

40.3

40.1
Designer: Luigi Montini
1986 Switzerland
Client: Museo Cantonale D'Arte
 Museum Logo
 This abstracted TYPE*face* with its single eye, appears to be looking at the viewer. This "MCA" logo has the "C" as the eye, "M" as mouth or mustache, the inner triangle above the "M" becomes the nose.
Principle Type: Handlettered

40.2
Designer: Ken Cato
1980 Australia
Client: The Adelaide Festival
 Arts Festival Logo
 This mask-like TYPE*face* is a stylized "A" for Adelaide. The face symbolizes both the performers and the audience.
Principle Type: Handlettered

40.3
Designer: Jackie Foshang
1987 U.S.
Client: Academy of Achievement
 Acting School Logo
 The TYPE*face* of the letter "A" contains in its negative space a starstruck face.
Principle Type: Handlettered

41.1
Designer: Michael Schwab
1991 U.S.
Client: Andreson Typographics
 Typeface design
 This TYPE*face* utilizes a meaningless umlaut to define its face.
Principle Type: Plakatstil

41.2
Designer: Heinrich Wehmeier
1974 Germany
Client: Bagel Graphic Arts Institute
 Logo
 This TYPE*face* illustrates its function very well as a seeing "B".
Principle Type: Handlettered

41.3
Designer: Willem Sandberg
1966 Holland
Client: Promotional Booklet
 Illustration
 The two "B"s are TYPE*faces*, one speaks, the other looks.
Principle Type: Fortune

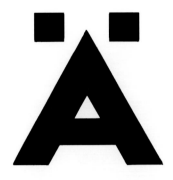

41.1

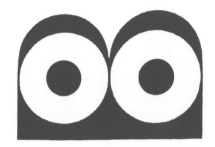

41.2

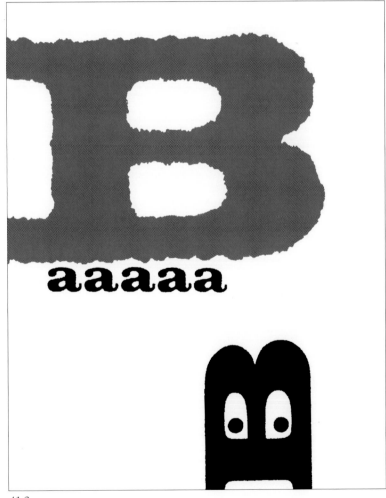

41.3

42.1
Designer: G. Dean Smith
1963 U.S.
Client: Cornnuts Inc.
 Snack Food Logo
 This classic TYPE*face* has no extra parts. The
 "C" is defined by its smiling, hungry mouth.
Principle Type: Handlettered

42.2
Designer: Jay Hanson
1969 U.S.
Client: Comprenetics, Inc.
 Logo for a training system
 The TYPE*face* is a stylized "C", with an arrow
 nose, to show direction.
Principle Type: Handlettered

42.3
Designer: Gerry Rosentswieg
1987 U.S.
Client: Children's Hospital, Los Angeles
 Proposed logo
 This TYPE*face* is a series of "Cs", making face
 shape, nose and mouth. Two dots are the eyes.
Principle Type: Handlettered

43.1
Designer: Kyösti Varis
1965 Finland
Client: Colombia-kahvilat
 Logo for a restaurant chain
 This TYPE*face*, the letter "C" with a spoon in
 its mouth, is a perfect symbol for eating.
Principle Type: Handlettered

43.2
Designer: Frank Varela
1994 U.S.
Client: Claudia Galuppo
 Logo for a Photographer
 This letter "C" TYPE*face*, with a camera lens
 eye, has a womans mouth to give it personality.
Principle Type: Handlettered

43.3
Designer: William Wondriska
1963 U.S.
Client: City Diaper Service
 Logo
 This TYPE*face* "C" is a baby's face.
 Principle Type: Handlettered

43.4
Designer: John Swieter,
Paul Munsterman
1993 U.S.
Client: Consolidated Couriers
 Logo for a messenger service
 A winged "C" TYPE*face*.
Principle Type: Handlettered

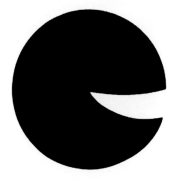

42.1

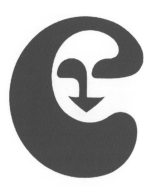

42.2

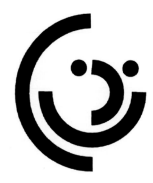

42.3

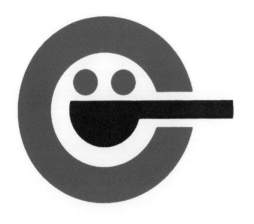

43.1

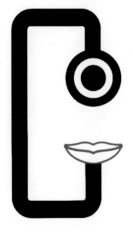

43.2

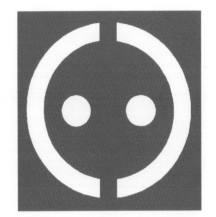

43.3

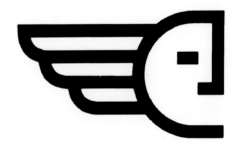

43.4

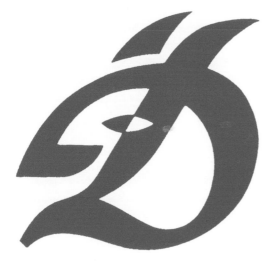

44.1

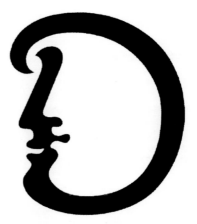

44.2

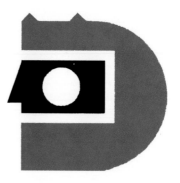

44.3

44.1
Designer: Nickolay Pecaroff
1989 Bulgaria
Client: Devil's Nightclub
 Discothecque Logo
 This TYPE*face* is a finely drawn
 script devil "D"
Principle Type: Handlettered

44.2
Designer: Stephan Kantscheff
1988 Bulgaria
Client: DesArt
 Designer's Organization
 This TYPE*face* "D" becomes
 the designers. Note that the
 two silhouettes are different.
Principle Type: Handlettered

44.3
Designer: James Dickens
1994 U.S.
Client: Self promotion
 Photographers logo
 This "D" TYPE*face* is both face
 and camera.
 Principle Type: Handlettered

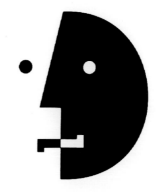

45.1

45.1
Designer: Scott Ray/Peterson & Co.
1990 U.S.
Client: Dallas Repertory Theatre
 Logo
 This TYPE*face* "D" interprets
 the masks of comedy and tragedy.
Principle Type: Handlettered

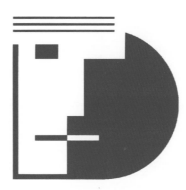

45.2

45.2
Designer: Dan McNulty
1990 U.S.
Client: The Dobal Company
 Logo for an entertainment
 industry business
 This masklike TYPE*face* is a
 modern "D" for the client's name.
Principle Type: Handlettered

45.3
Designer: Gerd Leufert
1955 Venezuela
Client: Pierre Denis Antiques
 Logo
 The letter "D" TYPE*face* has a
 fine face drawn into the shank
 of the letter.
Principle Type: Handlettered

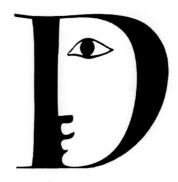

45.3

46.1
Designer: John Van Hamersveld
1991 U.S.
Client: Self Promotion
 Man symbol for the year 2000
 This TYPE*face* is E-Man, an icon
 for the 21st Century.
Principle Type: Computer

46.2
Designer: Freeman Lau Siu-hong
AD: Kan Tai-keung
1989 Hong Kong
Client: East East Wonton Noodle Ltd.
 Logo for a noodle restaurant chain
 This "e" becomes hair and bangs, and with
 the addition of a line and two dots creates a
 very stong TYPE*face*.
Principle Type: Handlettered

47.1
Designer: Jim Wood
AD: Robert Guidi/Tri-Arts
1960 U.S.
Client: Gore Engraving
 Small space ad
 This mostly drawn TYPE*face* has
 an italic "G" for its mouth, and
 on occasion, the rest of the letters
 as teeth.
Principle Type: Handlettered

47.2
Designer: Hiroshi Ohchi
1962 Japan
Client: Graphic Design in Japan
 Exhibition Poster
 The letter "g" stands for graphic
 design, and the negative spaces in
 this TYPE*face* become the eyes of
 the viewer. The descender of the
 letter becomes a happy mouth.
Principle Type: Handlettered

47.3
Designer: Gerry Rosentswieg
1978 U.S.
Client: Garrett Productions
 Logo for a TV production company
 This smiling TYPE*face* "G" has a modified
 negative space and eyes, an early happy face
 for a comedy producer.
Principle Type: Handlettered

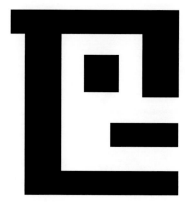

46.1

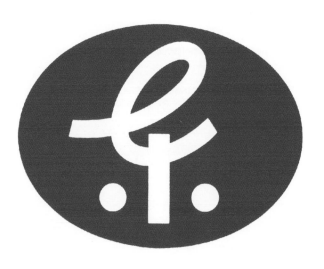

46.2

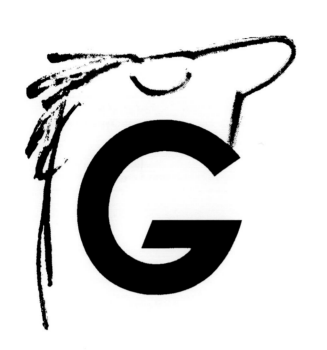

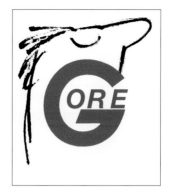

47.1

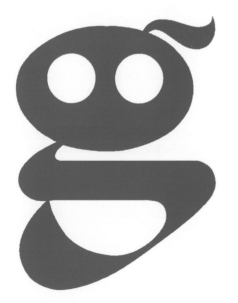

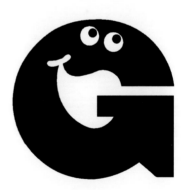

47.2

47.3

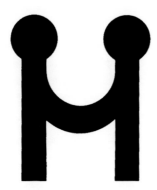

48.1

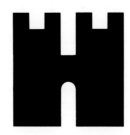

48.2

48.3

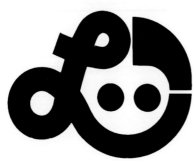

48.4

48.1
Designer: Pentti Vartiainen
1973 Finland
Client: Happy Hotels, Inc.
 Logo
 This TYPE*face*, a prototypical happy face, also acts as two people shaking hands. Whichever the viewer sees, it is an excellent icon for the hospitality industry.
Principle Type: Computer

48.2
Designer: Ribas & Creus
1974 Spain
Client: Asociatión del Hospitalario
 Logo
 This "H" TYPE*face* is both a castle and a primitive face. The negative space becomes eyes, nose and mouth.
Principle Type: Handlettered

48.3
Designer: Hiroshi Ohchi
1989 Japan
Client: Tokyo Juki Co., Ltd.
 Logo
 This "J" TYPE*face*, is a simple primitive face, The negative interior space becomes both eye and nose.
Principle Type: Handlettered

48.4
Designer: Joe Vera
1970 Mexico
Client: Lili Ledy
 Toy Manufacturer's Logo
 The script "L" defines the face and acts as hair; the lower swoop becomes the mouth.
Principle Type: Handlettered

49.1
Designer: Paul Rand
1990 U.S.
Client: Monell Chemical Senses Center
 Logo
 This silhouette TYPE*face* clearly alerts the viewer to which sense this "M" refers. The wavy line also reads as fumes.
Principle Type: Handlettered

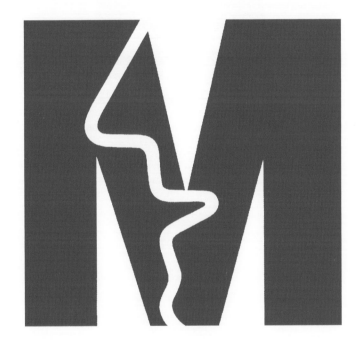

49.1.

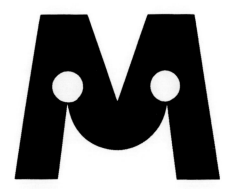

50.1

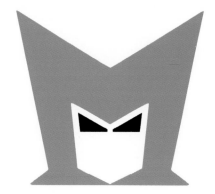

50.2

50.1
Designer: Robert Overby
1987 U.S
Client: Robert Overby
 Logo/Illustration
 This TYPE*face*, another happy face,
 is titled *Eye Nose Eye Smile* and
 is exactly that.
Principle Type : Handlettered

50.2
Designer: Robert Goodman
1987 U.S
Client: Mephisto Shoes
 Logo
 This Devil, allows the points of
 the handdrawn"M" to be the devils horns,
 The interior space defines the face, and the
 triangle eyes complete the TYPE*face*.
Principle Type : Handlettered

51.1
Designer: Clarence Lee
1973 U.S.
Client: Midpac Trucking
 Logo
 This "M" on wheels is also a simple
 TYPE*facee* with brow, nose and eyes.It
 becomes a truck and the firm watching
 over goods to be moved.
Principle Type: Handlettered

51.2
Designer: Jay Vigon
1984 U.S.
Client: Max Studio
 Proposed Logo for a clothing line
 The "M" becomes the face;
 the upper serifs the hair with the negative
 area under the nose becoming the mouth.
Principle Type: Handlettered

51.3
Designer: Frank Varela
1994 U.S
Client: Maria Canals
 Personal Mark for an Actress
 This heart shaped "M" TYPE*face*,
 has a tragedy/comedy mouth.
Principle Type : Handlettered

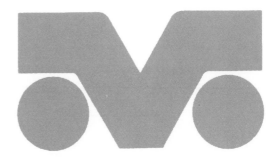

51.1

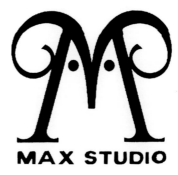

MAX STUDIO

51.2

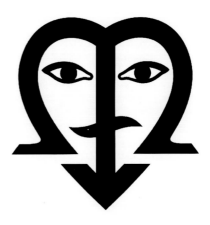

51.3

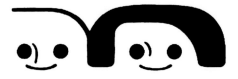

52.1

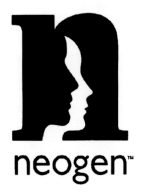

52.2

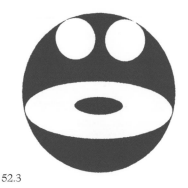

52.3

52.1
Designer: Hiroshi Ohchi
1961 Japan
Client: Nagai Foods, Inc.
 Logo
 This "n" makes a female and male
 TYPE*face*, cleverly using the body of the
 "n" as one face shape and the serif as
 another.
Principle Type: Handlettered

52.2
Designer: Michael Osborn
1993 U.S
Client: Neogen
 Logo for a nutritional and healthcare
 network marketing company
 This "N" TYPE*face,* defines two faces
 in its negative space.
Principle Type: Handlettered

52.3
Designer: Yusaku Kamekura
1980 Japan
Client: Nikon
 Proposed Divisional Logo
 This "O," with eyes and perspective
 mouth, displays a sense of humor not usu
 ally found in corporate marks. This mark
 both looks and displays a depth perception
 that defines what a camera is.
Principle Type: Handlettered

53.1
Designer: Tom Ohmer/Ad Designers
1977 U.S
Client: Chris Ohman
 Personal Logo
 This TYPE*face,* a rebus, spells
 out the client's name - O+man
Principle Type: Bauer Bodoni

53.2
Designer: Tadashi Ohashi
1986 Japan
Client: Omura Kindergarten
 Logo/Illustration
 This TYPE*face,* with basic simple
 shapes defines a child's face.
Principle Type: Handlettered

53.3
Designer: Hayashi Yoshio
1961 Japan
Client: Odakyu
 Logo for a Department Store
 The "O" becomes the face,
 the addition of two dots and a
 line make this a spare TYPE*face.*
Principle Type: Handlettered

53.1

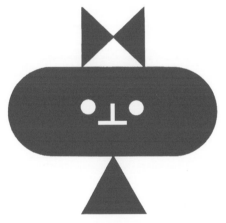

53.2

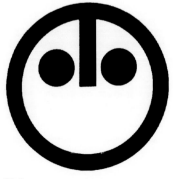

53.3

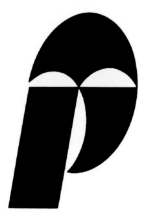

54.1

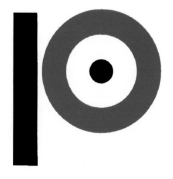

54.2

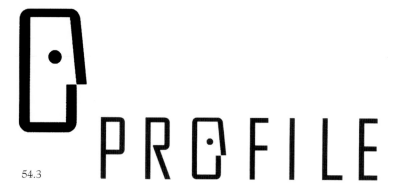

54.3

54.1
Designer: Yoneo Jinbo
1989 Japan
Client: The Pharmaceutical Society
 Logo
 This "P" is described as "the form of
a healthy man, living energetically." this mask
like design is an unusual face treatment.
Principle Type: Handlettered

54.2
Designer: Giovanni Brunazzi
1974 Italy
Client: Pino Torinese
 Logo for a Sports Club
 The "P" becomes a target and a face,
the descender the nose,the bowl of the
letter the eye.
Principle Type: Handlettered

54.3
Designer: Lorraine Charman
1994 U.S.
Client: The Rouse Company
 Masthead for a newsletter
 The "O" in the word "Profile" becomes a face
in profile,naturally. The right hand bowl of
the letter is altered to become the nose as
well as face shape.
Principle Type: Bureau Agency, modified

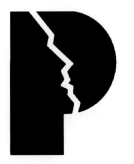

55.1

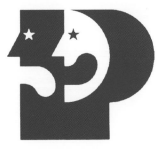

55.2

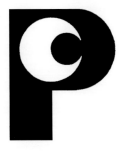

55.3

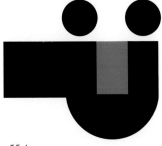

55.4

55.1
Designer: Scott Ray
1986 U.S
Client: Plano Crisis Center
Hotline Logo
This TYPE*face* is defined by the lightning-like profile.
Principle Type: Handlettered

55.2
Designer: F.R. Esteban
1983 U.S.
Client: Parable Players
Theatre Logo
This "P" encompasses the masks of comedy and tragedy and becomes a distinctive logo/ TYPE*face* for this little theatre.
Principle Type: Handlettered

55.3
Designer: Armin Hoffman
1964 Switzerland
Client: Pfauen Modehaus
Logo for a Clothing Manufacturer
The "P" becomes a face, the negative space is the eye and the stem acts as nose. This "P" eye becomes the viewer and the viewed for this fashion-house mark.
Principle Type: Handlettered

55.4
Designer: Ulf Petterson
1961 Sweden
Client: Investment Profectus
Logo
This "P" on its side becomes a character to watch over the company and its investments. The features also act as an "I" nose with a diacritical mark for eyes.
Principle Type: Handlettered

56.1
Designer: Sean Alatorre/Tom Bauman
AD: John Coy
1988 U.S
Client: The Riordan Foundation
 Logo
 This *italic "r"* TYPE*face* is modified
 so that the lobe becomes an eye
 and the body becomes a nose.
 The addition of a curved line
 is the smiling mouth for this non-
 profit learn-to-read project.
Principle Type: Modified Torino

57.1
Designer: Bob Aufuldish
1991 U.S.
Client: Robert Aufuldish
 Personal Logo
 This robot-like "R" is the
 mark of an illustrator/designer
 who is anything but robotic. The
 swell is modified creating the head
 of this TYPE*face*.
Principle Type: Handlettered

57.2
Designer: Jay Loucks
1974 U.S.
Client: Sandair
 Aviation Leasing Company Logo
 The "S", drawn so that negative
 space of the upper bowl becomes
 the cabin of an airplane shadowing
 the face, the upper serif acts as
 flowing hair with the airstream
 carrying the plane.
Principle Type: Handlettered

57.3
Designer: Gerry Rosentswieg
1987 U.S.
Client: Metromedia Producers
 Proposed Film Logo
 This "S" laying on its side
 becomes a masked character
 for the film, *"Stealing Home"*,
 a comedy about burglary.
Principle Type: Helvetica Inserat

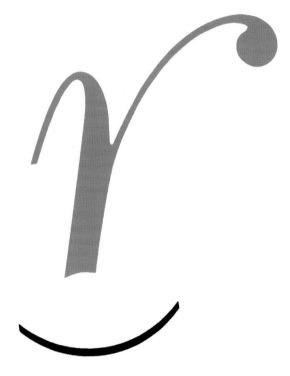

56.1

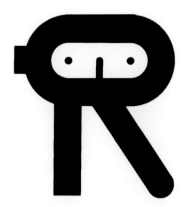

57.1

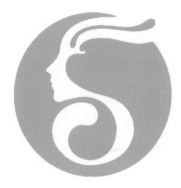

57.2

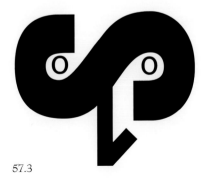

57.3

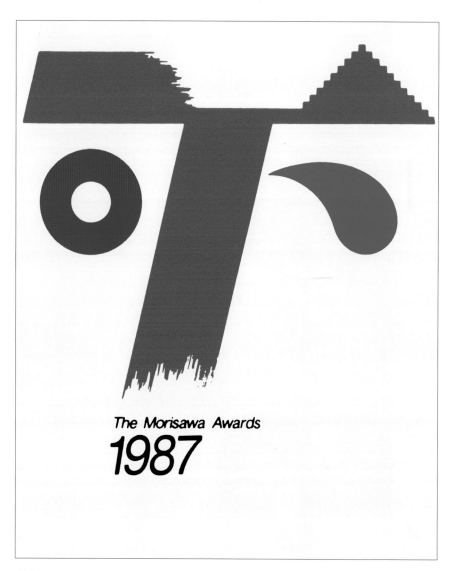

The Morisawa Awards
1987

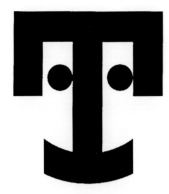

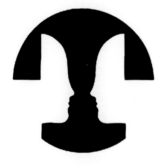

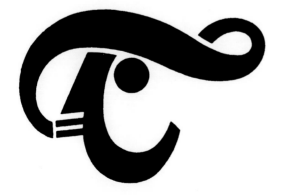

58.1
Designer: Toshiyasu Nanbu
1993 Japan
Client: Taste
　Logo for an Advertising Agency
　This Bart Simpson-like "t" is an eccentric lower case TYPE*face*. The cross-stroke becomes hair fringe and nose, the small triangle cut into the main body of the letter is the mouth.
Principle Type: Handlettered

58.2
Designer: Mitsui Katsui/Yutaka Sugimoto
1983 Japan
Client: Morisawa & Co.
　Mark for an International
　Typeface Competition
　The "T" for type, is a blend of Oriental and Western letter elements.
Principle Type: Handlettered

59.1
Designer: Gerry Rosentswieg
1974 U.S.
Client: Tenny Toys
　Proposed Logo
　This TYPE*face*, a slab-serif "T" with a curved base serif smiles at the viewer
Principle Type: Handlettered

59.2
Designer: Shigeo Fukuda
1983 Japan
Client: Tenjin Core
　Logo
　This "T" is drawn within a circle shape. The negative space becomes two faces in the manner of the old optical trick of faces/vase of flowers - depending on the positive or negative orientation of the viewer.
Principle Type: Handlettered

59.3
Designer: Karl Schulpig
1924 Germany
Client: Teneriffa Cigarette Co.
　Logo
　This swash "T" becomes a perfect TYPE*face*, the crossbar forming smoke and the bowl of the letter, the face.
Principle Type: Handlettered

60.1
Designer: Jay Vigon
AD: Vigon Seireeni
1985 U.S.
Client: Robert Bane, Inc./
Tamara Bane Gallery
 Art Gallery Logo
 This "T" with an arched crossbar
forming eyebrows is a stylish TYPE*face.*
Principle Type: Handlettered

60.2
Designer: Jay Vigon
AD: Vigon Seireeni
1985 U.S.
Client: Robert Bane, Inc./
Tamara Bane Gallery
 Art Gallery Logo
 This "T" with a waving crossbar
forms a winking eye, the "G" for
gallery is the mouth.
Principle Type: Handlettered

60.3
Designer: Jay Vigon
AD: Vigon Seireeni
1985 U.S.
Client: Robert Bane, Inc./
Tamara Bane Gallery
 Art Gallery Logo
 This scribbled "T" becomes
an ccentric form designed to be a
freestanding sculpture
Principle Type: Handlettered

61.1
Designer: Margo Chase
1987 U.S.
Client: Virgin Records
 Logo
 This woodcut "V" TYPE*face* is more
drawing than type. The negative crotch
of the letter defines the face. The
attitude of the drawing seems to be making
a cool musical statement.
Principle Type: Handlettered

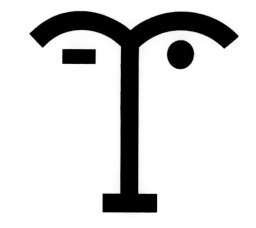

60.1

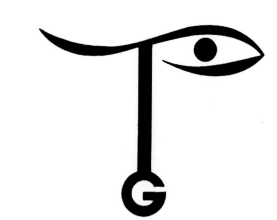

60.2

60.3

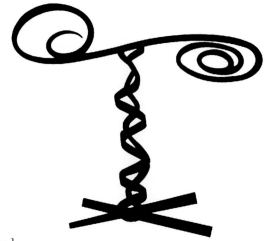

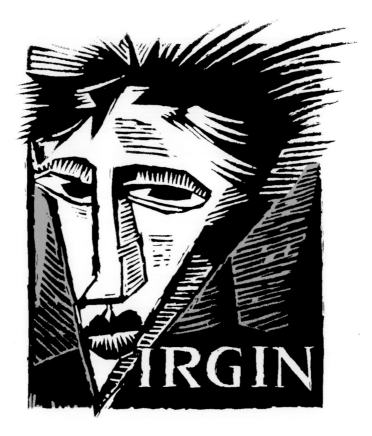

61.1

62.1
Designer: Paul Ibou
1969 Belgium
Client: West-End Bally
 Shoe Company Logo
 This "W" truncated and with ends
 straightened becomes a clownlike
 TYPE*face* for this children's
 shoe company.
Principle Type: Handlettered

62.2
Designer: Roman Duszek
1990 U.S.
Client: Walnut Street Gallery
 Art Gallery Logo
 This "W" with wavy hair
 becomes an abstracted TYPE*face*.
 The eye, a natural symbol for
 an art gellery, defines the face. The
 negative space below the eye
 becomes the nose.
Principle Type: Handlettered

62.3
Designer: Allan Waley
1990 U.S.
Client: Allan Waley
 Personal Mark
 This classic TYPE*face* "W," with
 the addition of two dots and a
 decorative dingbat, becomes a
 self-portrait of the designer.
Principle Type: Bodoni

63.1
Designer: Kazumasa Nagai
1992 Japan
Client: Yasuda Mutual Life
 Logo
 This very spare, very stylish TYPE*face*
 is western, the "Y" for Yasuda
 is a western character. But the
 styling and feel of this mark is
 eastern and resembles a kanji figure.
 The left arm of the "Y" swoops
 down to become profile and nose,
 The right arm is drawn as an eye.
Principle Type: Handlettered

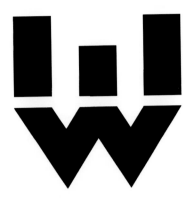

62.1

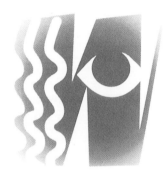

62.2

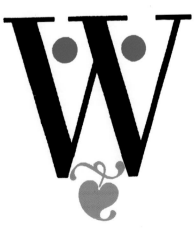

62.3

63.1

64.1
Designer: Paul Rand
1960 U.S.
Client: Westinghouse Electric Corporation
 Logo
 This electrical "W" with its
 series of dots and dashes, becomes
 a TYPE*face*. The dots read as eyes, the
 triangle beneath the middle dot, the nose,
 and the rounded slot becomes a mouth.
 All this and plug-like, electrically too.
Principle Type: Handlettered

64.2
Designer: David Roditi
1989 Great Britain
Client: I-X Child Guidance
 Play Therapy Icon
 This bold "X" TYPE*face* with eyes
 is both a mask with a negative
 triangle nose and a playing child,
 standing on his hands.
Principle Type: Gill Sans Black

64.3
Designer: Samuel Aznar
1991 Spain
Client: City of Zaragoza
 Convention Bureau Logo
 This circular TYPE*face* is a classic.
 the "Z" becomes the nose, the black
 arc with becomes mouth and teeth,
 The additional type defines the face,
 and the dots the eyes.
Principle Type: Handlettered

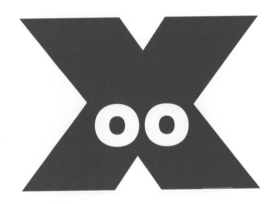

64.1

64.2

64.3

OFICINA DE CONGRESOS
CONVENTION BUREAU
ZARAGOZA

Multiple character **TYPE***faces. This group of icons is designed with any number of letters, and amplified with dots, type sorts and dingbats. These icons and logos are a compendium of humanized approaches to the art of identity, they remain popular and memorable -*

MULTIPLE
CHARACTER
TYPE*faces*

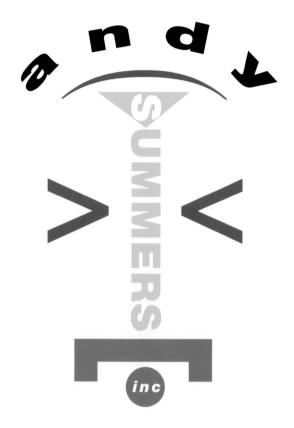

66.1

66.1
Designer: Norman Moore
1991 U.S
Client: Andy Summers
 Personal Mark
 This TYPE*face* is abstracted: it
 can be viewed as face or person.
 "andy" is the hair, "SUMMERS"
 the nose, the "V" shapes become
 eyes, the square "C" is the mouth,
 and the "inc" ball the tongue.
Principle Type: Various

67.1
Designer: Amos & Power
1960 Great Britain
Client: Amos & Power
 Advertising Agency Logo
 This *lower case* "ap" becomes
 a looking TYPE*face,* a distinctive
 logo for an agency.
Principle Type: Handlettered

67.2
Designer: Peter Steiner/
Michael Friedland
AD: Gottschalk + Ash
1982 Canada
Client: Parc Belmont
 Logo for an Amusement Park
 The "B" becomes the face shape,
 the hat becomes the bowl of the "P"
 and the face is drawn in.
 Principle Type: Handlettered

67.3
Designer: Rumsey Lundquist
1970 U.S.
Client: Brown Photo
 Logo for Photo Processing
 The "bp" isTYPE*face* and the
 eyes of the photographer.
Principle Type: Handlettered

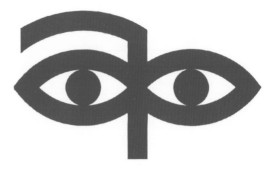

67.1

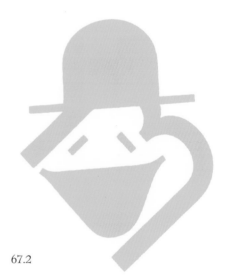

67.2

67.3

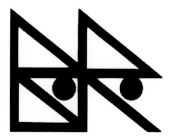

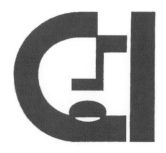

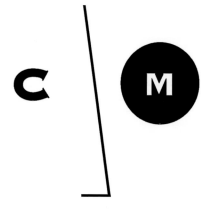

68.1
Designer: Ben Rosen
1971 U.S.
Client: Ben Rosen Associates
 Design Studio Mark
 This TYPE*face* "BR," with the addition
 of two dots becomes eyebrows, eyes
 and nose.
Principle Type: Handlettered

68.2
Designer: Scott Greir
1992 U.S.
Client: Communication Institute
University of Utah
 Logo
 The "CI" becomes the shape
 of this TYPE*face*, the drawn features
 are simple and dramatic.
Principle Type: Handlettered

68.3
Designer: Dana Shields
AD: Andy Dreyfus
CKS Partners
1993 U.S.
Client: Dr. Charles Merker,
 Logo for an Opthalmologist
 The initials are the eyes, the circle
 which holds the "M", becomes an
 eyeglass icon. The drawn nose fully
 defines this TYPE*face*.
Principle Type: Handlettered

69.1/69.2
Designers: Lai-Kit Chan / Michael Chikamura /
Andrew Fukutome
1994 U.S.
Client: Chikamura Design
 Identity for a Design Studio
 The initials are the eyes, the circles with the
 addition of an arc becomes eyeglasses. The
 copy is nose, hair and mouth for this identity
 system TYPE*face*.
Principle Type: Various

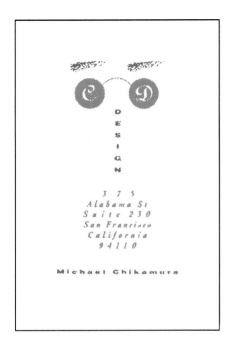

69.1

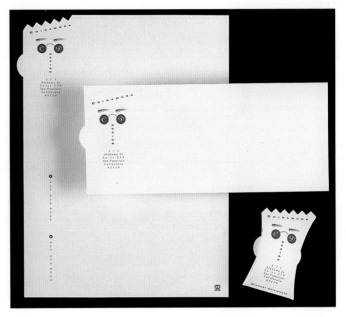

69.2

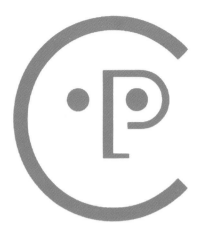

70.1

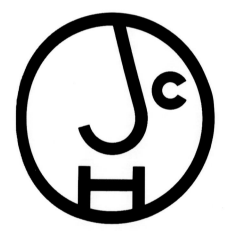

70.2

70.2

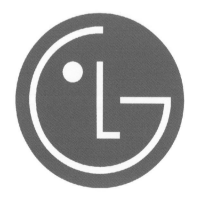

70.3

70.1
Designer: Malcolm Grear
1990 U.S
Client: Community Preparatory School
 Hotline Logo
 This playful TYPE*face* reflects the imagina
 tion of a child. The "C" is the face shape,
 the "P" becomes eye socket and nose.
Principle Type: San Serif

70.2
Designer: Michael McGinn
1988 U.S.
Client: J.C.H. Telegraphics
 Logo
 Like the mark above, this logoTYPE*face*
 is a playful treatment of the company's
 initials. At right is a poster/ announce-
 ment with the letters/face diecut.
Principle Type: Handlettered

70.3
Designer: Cathy-Ann Martine
1992 Korea
Client: Lucky Goldstar
 Logo
 The letters, reversed from the faceshape
 make this logo a TYPE*face*. The "L"
 becomes nose. The period/dot is an eye.
Principle Type: Handlettered

71.1
Designer: Burton Kramer
1974 Canada
Client: Creative Playgrounds
 Logo for a Toy Manufacturer
 The "CP" becomes a face and eyes, the
 descender of the "P" is shortened and acts
 as nose.This mark has a toy-like feeling.
Principle Type: Handlettered

71.2
Designer: Dicken Castro
1991 Colombia
Client: Junta de Contradores
 Logo for a firm that supplies
 office workers
 The "J" is nose and face shape, the "C"s
 become owlike eyes in this TYPE*face*.
Principle Type: Handlettered

71.3
Designer: Bruno Pippa
1957 Italy
Client: Conificio Optico
 Logo
 The "C" is nose and face shape, the "o"s
 become eyes and glasses. This Picasso-like
 TYPE*face* is profile and full face at once.
Principle Type: Handlettered

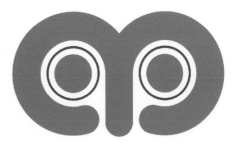

71.1

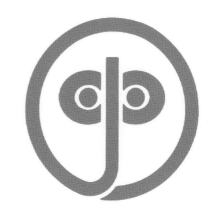

71.2

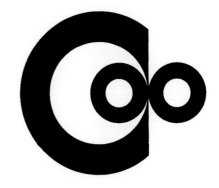

71.3

[71]

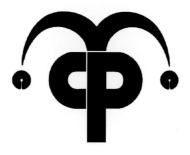

72.1

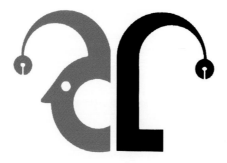

72.2

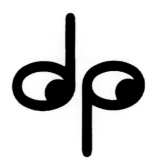

72.3

72.1
Designer: Arnold Schwartzman
1980 Great Britain
Client: Creative Partners Ltd.
 Logo for a Screenwriting Group
 This jester TYPE*face* uses the negative space of the "cP" as eyes and the stem of the "P" as a nose.
Principle Type: Handlettered

72.2
Designer: Thomas DiPaolo
1988 Germany
Client: C.Lewis
 Logo for a Comedy Writer
 This "CL" TYPE*face* with the addition of a nose and an eye is another treatment of the jester .
Principle Type: Handlettered

72.3
Designer: Niclay Pecareff
1980 Bulgaria
Client: Dark Plays
 Logo for a Rock Group
 The "dp" acts as eyes and nose in this inquisitive TYPE*face*.
Principle Type: Handlettered

73.1
Designer: William Meehan
1971 U.S.
Client: University Little Theatre
 Logo
 These "D"s become the masks of theatre as well as the "D" for Depauw University in this TYPE*face*.
Principle Type: Handlettered

73.2
Designer: Terry Fleischman
1973 U.S.
Client: Denver Artists Guild
 Logo
 This straightforward TYPE*face* uses the letters as eyes and mouth. The dot of a nose ties the face together
Principle Type: Handlettered

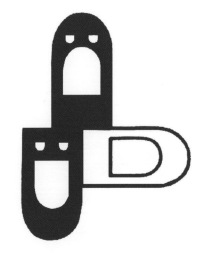

73.1

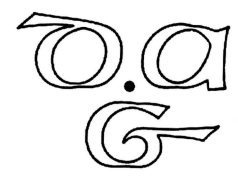

73.2

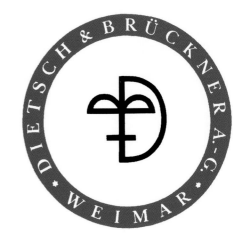

74.2

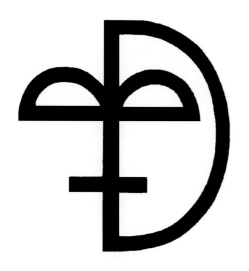

74.1

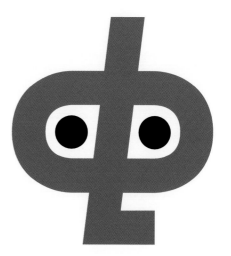

74.3

74.1/.2
Designer: Walter Kersting
1952 Germany
Client: Dietsch & Bruckner
 Logo for a Printer
 This TYPE*face* is totally made by
 the "D+B". Used separately or
 with the copy ring, it is a wonderful
 example of a corporate *TYPEface*.
Principle Type: Handlettered

74.3
Designer: Norman Moore
1994 U.S.
Client: Epitaph Records
 Down By Law Logo
 This "dbL" with the addition
 of two dots, becomes mask, eyes
 and nose for this TYPE*face*.
Principle Type: Handlettered

75.1 75.2 75.3
Designer: Joseph Gault
AD Tiit Telmet
1989 Canada
Client: Dance Umbrella of Ontario
 Logo for an Organization of
 Choreographers
 These "DUO" variations act as
 face and dancing features in this
 rubbery TYPE*face*.
Principle Type: Univers, Times
and Bodoni.

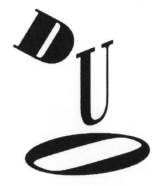

75.1

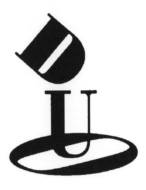

75.2

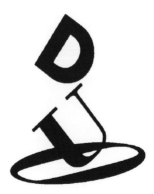

75.3

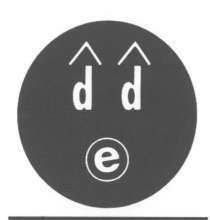

76.1

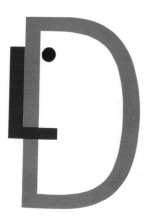

76.2

76.1
Designer: Daniel P. Smith/
Richard A Smith
1994 U.S
Client: Double Entendre
 Design Studio Logo
 This circle TYPE*face* has features
 made from type and sorts. The studio
 is run by twin brothers, the mark
 addresses all the plays on words of
 this mark.
Principle Type: Franklin Family

76.2
Designer: Hartmut Bruckner
1990 Germany
Client: DesignLabor, Bremerhaven
 Design Studio Logo
 This TYPE*face* has an "L" nose on
 a "D" faceshape. The blue period/dot
 is an eye.
Principle Type: Rotis Grotesk

77.1
Designer: Sam Smidt
1975 U.S.
Client: Eye
 Optical Shop Logo
 The double lettering of this
 mark defines the glasses and the
 eyes of this TYPE*face*.
Principle Type: Handlettered

77.2
Designer: Robin Rickabaugh
1993 U.S.
Client: Scott Hall
 Illustration for an artists reps publication,
 The World of Classic Idioms
 "The Apple of My Eye", this
 TYPE*face* is eyes and nose, with quote
 eyelashes and dotted rule mouth.
Principle Type: Franklin

77.3
Designer: Gerry Rosentswieg
1992 U.S.
Client: E L E Opticians
 Logo
 This TYPE*face* illustration is *a*
 playful mark for an upscale
 opticle shop.
Principle Type: Handlettered

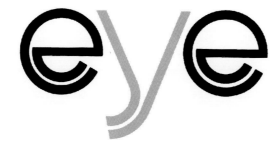

77.1

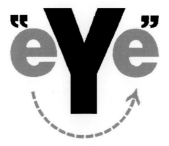

77.2

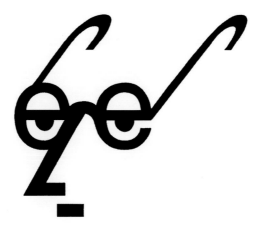

77.3

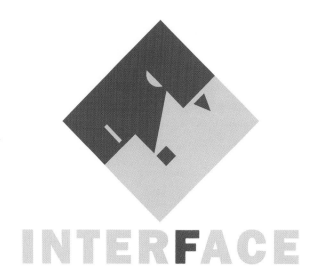

78.1

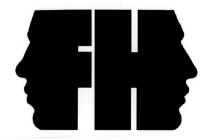

78.2

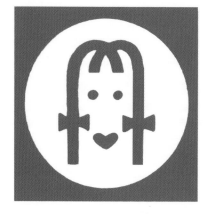

78.3

78.1
Designer: Norman Moore
1990 U.S
Client: Gore Graphics
 Logo for Interface Digital PrePress
 This TYPE*face* is abstracted "F"s.
Principle Type: Handlettered

78.2
Designer: Carlos Rolando
1974 Spain
Client: Factor Humano
 Public Relations Firm Logo
 These initial profiles of the principals creates a
 strong personlity in this distinctive TYPE*face*.
Principle Type: Handlettered

78.3
Designer: Rodney Chirpe
1962 Canada
Client: Faro & Faro
 Logo for a Manufacturer of
 Young Women's Clothes
 The mirrored "f" becomes face shape
 and pigtails in this TYPE*face*. The
 addition of dots, heart and triangles
 finish the face.
Principle Type: Handlettered

79.1
Designer: Michael D. Geiser/
Maray Design Group
1992 U.S.
Client: Gregory Thompson Organization
 Logo for a Manufacturing Company
 The "G" and "O" become the eyes
 and the negative "T" the nose for
 this TYPE*face*.
Principle Type: Handlettered

79.2
Designer: Dipak H. Patel
1988 India
Client: Gohil Fashion
 Logo for a Mens Shop
 The "G" defines this TYPE*face*,
 the "F" is an unneccessary
 appendage, and the hat finishes
 and becomes serif for the "G".
Principle Type: Handlettered

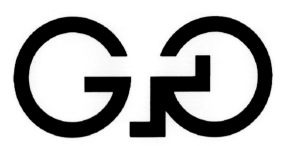

79.1

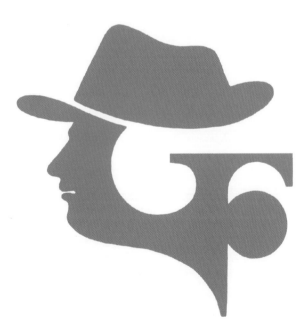

79.2

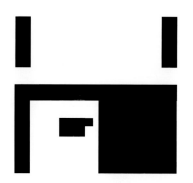

80.1

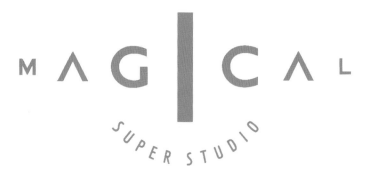

80.2

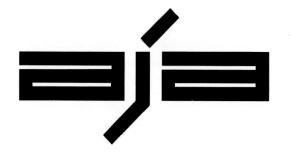

80.3

80.1
Designer: Densler Design
1959 U.S
Client: B. C. Holland Gallery
 Art Gallery Logo
 This TYPE*face* is quite abstract for
 its period. The negative space below
 the crossbar becomes the face shape in
 this geometric square "H". The eye is a
 "b" laying on its side, and the negative
 face shape becomes a square "C".
Principle Type: Handlettered

80.2
Designer: Kiyoshi Shimizu
1993 Japan
Client: Magical
 Design Studio Logo
 The graded sizes of the letters and the
 curved line of type for this happy face mark,
 makes eyes of the "G" and "C" and a nose
 of the "I".
Principle Type: Handlettered

80.3
Designer: Hirofumi Iwai
1981 Japan
Client: AJA
 Logo for an Organization
 The "a"s are the eyes and the "j"
 the nose in this TYPE*face*.
Principle Type: Handlettered

81.1
Designer: Richard Foy/
Communication Arts
1987 U.S.
Client: Broadway Plaza
 Logo/Illustration for an
 International Collection Promotion
 The "I" is the nose and the "C"
 is the eye in this TYPE*face*.
Principle Type: Handlettered

INTERNATIONAL COLLECTION

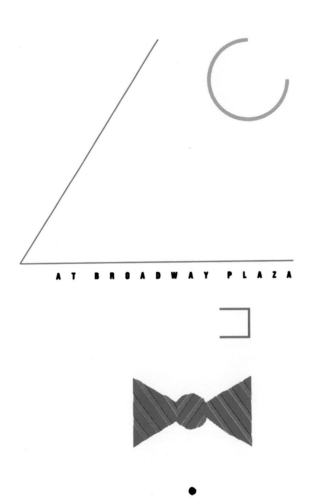

AT BROADWAY PLAZA

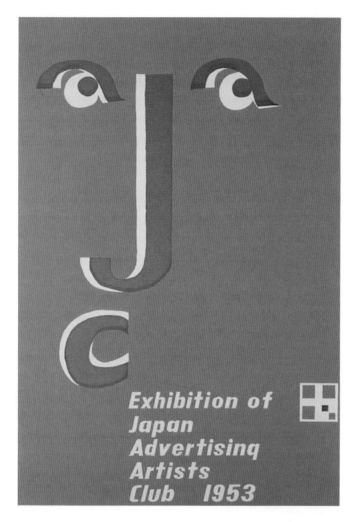

82.1

82.1

Designer: Kenji Itoh
1953 Japan
Client: Japan Advertising Artists Club
 Poster
 This TYPE*face* poster for the first exhibition
 of the clubs' work, uses their initials artfully
 placed to represent a face.
Principle Type: Handlettered

83.1

Designer: Emil Preetorius
1919 Germany
Client: K&B Verlag (Publishers)
 This typical publishers signet becomes a
 TYPE*face*, the "K" and "B" are the eyes, the
 arrow shape ending in a "V" is a rather mewling
 mouth. The horizontal lines are the nose.
Principle Type: Handlettered

83.2

Designer: Robyn Lewis
1994 U.S.
Client: Robyn Lewis Graphic Design
 Logo for a Design Studio
 This shield becomes a TYPE*face* the "R",
 "J" and "L" become the features.
Principle Type: Handlettered

83.3

Designer: Peter Muller-Munk
1971 U.S.
Client: Louisiana Stadium
 Logo
 The initials become a symbol for the
 audience in this strong TYPE*face*.
Principle Type: Handlettered

83.4

Designer: Gerry Rosentswieg
1990 U.S.
Client: Art Directors Club of Los Angeles
 Icon for a Mailer
 Several designers contributed to a project
 to celebrate the club's 50th year. In this
 half of Los Angeles the "L" is the nose, the
 "O" is the eye, and the "S" a bold mouth.
Principle Type: Handlettered

83.5

Designer: John L. Ball/Solutions By Design
1990 U.S.
Client: Learning Enterprises
 Logo for Multilingual Interpreters
 The "L" is the nose, the "O" is the eye,
 and the "E" rather aggressive kissing lips.
Principle Type: Handlettered

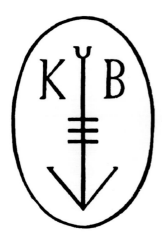

83.1

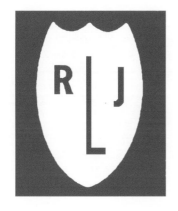

83.2

83.3

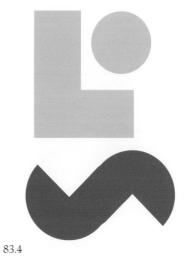

83.4

83.5

84.1
Designer: Malcolm Grear
1973 U.S.
Client: Morris Museum of Arts
Logo
This TYPE*face* for the museum is an
unusual placing of initials, with the negative
spaces becoming eyes and mouth.
Principle Type: Venus

84.2
Designer: Michael Hensel
1922 Germany
Client: Self
Promotional Logo
This strange creature becomes a
TYPE*face*, the "M" and "H" becomes
framework for the face and complete
figure as well.
Principle Type: Handlettered

84.3
Designer: Karl Schulpig
1924 Germany
Client: Mensing Company
 Logo for a Mens Clothing Store
This "M" becomes shoulders and
neck for this TYPE*face*.
Principle Type: Handlettered

85.1
Designer: John Sayles
1994 U.S.
Client: James River Corporation
 Illustration for a paper promotion
The initials "M" and "O"
become hat, face and mouth in this
constructivist TYPE*face*.
Principle Type: Handlettered

85.2
Designer: Georges Levoinel
1933 France
Client: ElectroVox Corporation
 Symbol for a Phonograph Company
The hair of this musical TYPE*face* is
the type of ELECTRO, and the "O"
a perfect record mouth.
Principle Type: Handlettered

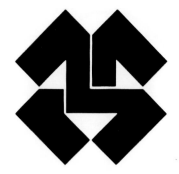

84.1

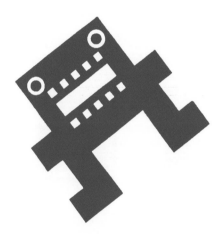

84.2

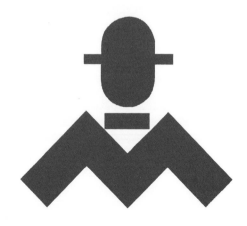

84.3

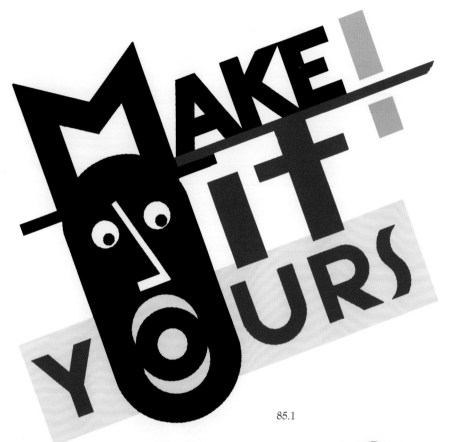

85.1

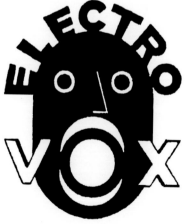

85.2

86.1
Designer: Norman Moore
1993 U.S.
Client: Polygram Records
Record Company Logo
This TYPE*face* for the Moody Blues Live
from Red Rocks Amphitheatre is both the
"MB" logo, face and eyes, and the theatre
rows, the mouth.
Principle Type: Handlettered

86.2
Designer: Michael Salisbury
1990 U.S.
Client: Self
Promotional Logo for an advertising agency
This winking TYPE*face,* the "M" and "S"
become the eyes for this company famous
for its sense of humor.
Principle Type: Handlettered

87.1
Designer: Sam Shelton/Jeff Fabian
1989 U.S.
Client: Art Directors Club of Washington D.C.
 Illustrations for a lecture by a deconstructivist
 typographer
These TYPE*faces* echo the playful treatment
of type on this broadside poster. Also shown
are details of the face devices.
Principle Type: Various

86.1

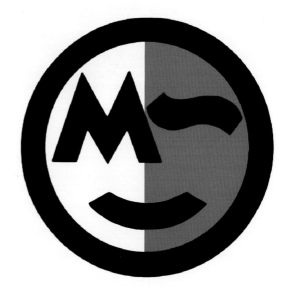

86.2

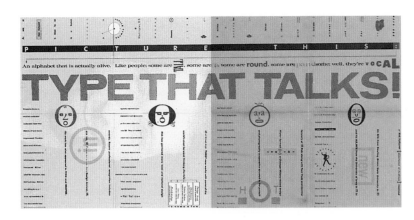

871

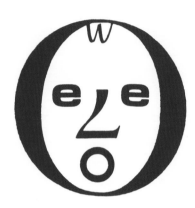

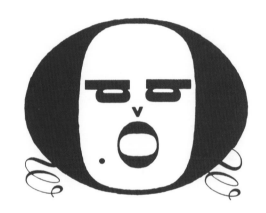

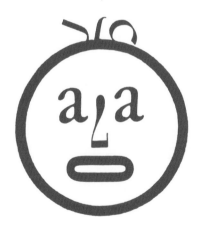

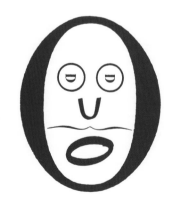

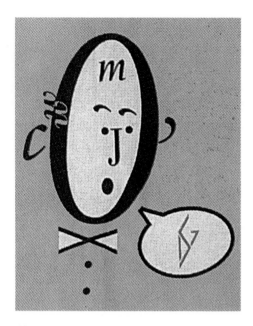

88.1

88.1
Designer: Andrew Polan
AD:Supon Phornirunlit
1991 U.S.
Client: Art Directors Club of Cincinatti
 Announcement Illustration
 This TYPE*face* announcing a
meeting is simply a playful selection
of type and sorts.
Principle Type: Various

89.1
Designer: Brian Jackson
AD: Larry Vigon
1990 U.S.
Client: Ocean Pacific Surfwear
Promotional Logo
 The TYPE*face* not only suggests the
face of the surfer but the paper bag
in which he brings his purchase home.
Principle Type: Handlettered

89.2
Designer: Paul Rand
1981 U.S.
Client: IBM
Masthead/Logo
 "op" middle letters in the magazine title,
Topics, suggests the initials of the company
division, Office Products as well as a
subtle TYPE*faces.*
Principle Type: Franklin

89.3
Designer: Mo Lebowitz
1968 U.S.
Client: The Picture House Press, Inc.
 Logo for a Publisher
 The bowls of the "P's" for Picture
and Press and the "H" for House, the
mouth and nose becomes a TYPE*face* that
looks at the pictures produced.
Principle Type: Handlettered

89.4
Designer: Stephan Kanttscheff
1972 Bulgaria
Client: State Puppet Theatre
 Symbol for a Theatre
 This TYPE*face* is defined by the "O" face
and "P" eye and nose.
Principle Type: Handlettered

89.5
Designer: Claudio Doveri
1974 Italy
Client: General Data Processing, Milan
 Logo
 The three initials of this TYPE*face*
make the eyes, nose and mouth.
Principle Type: Handlettered

89.6
Designer: Tatsuo Okuno
1982 Japan
Client: The International Art
Theatre Foundation
 Symbol for a Drama Festival
 This weeping TYPE*face* is
the symbol for a production about
the theatre. Somewhat less hackneyed
than the traditional masks.
Principle Type: Handlettered

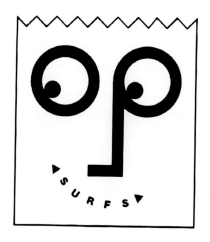

89.1

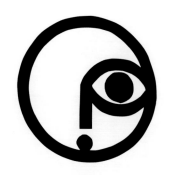

89.4

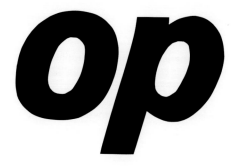

89.2

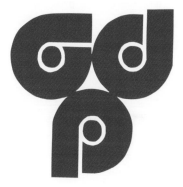

89.5

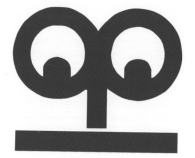

89.3

89.6

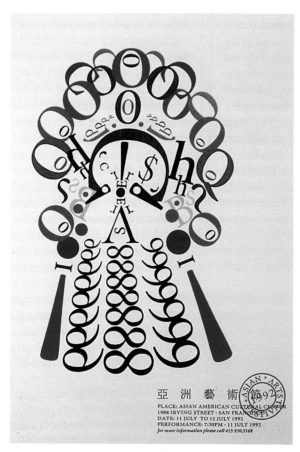

90.1

90.1
Designer: Chun-Wo Pat
ST: Pushpin Studio
1994 U.S.
Client: Yale Asian American Cultural Center
 Poster Illustration
 This poster TYPE*face* for an Asian Arts
 Festival gives Western letterforms the
 pictorial function usually reserved for Chinese
 characters. The image is a Chinese Opera
 traditional costume/mask.
 Principle Type: Various

90.2
Designer: Ng Chin Joon
AD: Ronnie S.C. Tan
1993 Hong Kong
Client: Candid Signs Pty. Ltd.
Logo for a Sign Fabrication company
 The type and sorts in this TYPE*face*
 become suggestive of the designer and
 fabricator in this personable logo.
 Principle Type: Various

91.1
Designer: Herb Lubalin
1968 U.S.
Client: American Institute of Graphic Arts
Typographic Self Portrait, misspelled
 This TYPE*face,* suggests a face, generic
 rather than actual, with the simplest of means.
Principle Type: Futura Extra Bold

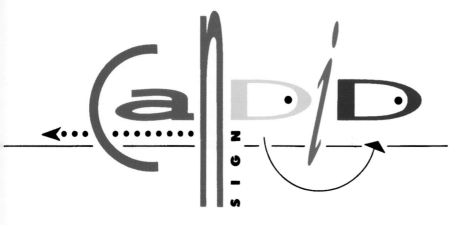

90.2

HERB LOOB-ALIN!

91.1

92.1
Designer: Linda Shibuya
1990 U.S.
Client: Rochas Dinner Theatre
 Logo
 This TYPE*face* portrays the typical blackguard villain with the swash of the "R"s. They act as mustache and eyes. The upside-down "T", for theatre, becomes the villains top hat.
Principle Type: Centaur

92.2
Designer: John Alcorn
1975 U.S.
Client: Rizzoli Ragazzi
 Logo for a Children's Publisher
 The reflecting "R"s become the eyes, nose and hair of this TYPE*face*.
Principle Type: Handlettered

92.3
Designer: W.S. Crawford Agency
1931 Great Britain
Client : George Mason & Company
 Brand Identity for a mint jelly
 This is a face and a body, a good representation of a retro TYPE*face*.
Principle Type: Handlettered

93.1
Designer: Karl Schulpig
1925 Germany
Client: Deutscher Sparkassen Und Giroverband
 Banking Services Logo
 This Mercury symbol TYPE*face* for a savings bank and clearing house uses type for all the features. Especially interesting is the "U" mouth.
Principle Type: Handlettered

93.2
Designer: Jim DeLuise
1990 U.S.
Client: KCRW, National Public Radio
 Masthead for a newsletter
 This abstract TYPE*face*, with "S" and "Ce" as eyes, and "L" as nose.
Principle Type: Futura Extra Bold

93.3
Designer: Jay Vigon
AD: Bill Burks
1990 U.S.
Client: EMI Records
 Proposed album title treatment
 The casual type in this TYPE*face* become a sneaky face.
Principle Type: Handlettered

92.1

92.2

92.3

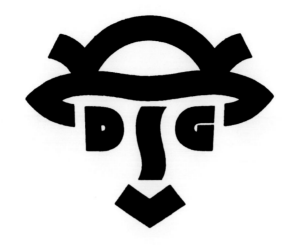

93.1

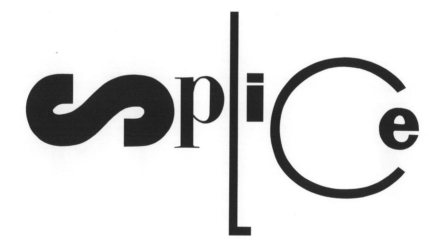

93.2

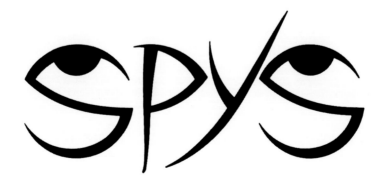

93.3

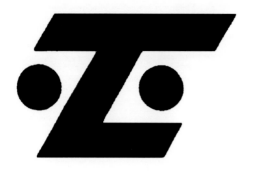

94.1

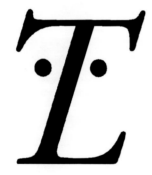

94.2

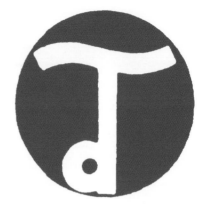

94.3

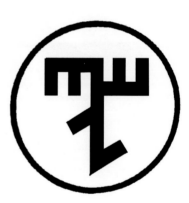

94.4

94.1 94.2
Designer: San Smidt
1962 U.S.
Client: Trade Litho Press
 Logo
 This TYPE*face* the uses its initials and the two
 dots to show the printer as well as the process.
1975 U.S.
Client: Trade Litho Press
 Logo
 This TYPE*face* is a revise of the earlier
 mark above, (94.1).
Principle Type: Handlettered

94.3
Designer: Philipp Seitz
1929 Germany
Client: unknown
 Logo
 This is an abstract face, eyes, nose and mouth.
Principle Type:Handlettered

94.4
Designer: Karl Bultmann
1923 Germany
Client: Zigarettenfabrik Mewes, Weisbaden
 Logo for a cigarette manufacturer
 This initial portrait TYPE*face* uses the block
 "M"s as eyes with pupils. The "Z" a mouth
 smoking a cigarette.
Principle Type: Handlettered

95.1
Designer: deMartin-Marona
1964 U.S.
Client: St. Regis Paper Company
 Brand Identity for school products.
 The negative space of the "T" defines the face.
Principle Type: Radiant Family

95.2
Designer: Saul Bass & Associates
1971 U.S.
Client: Lawry's
 Logo for an Italian restaurant division
 The placement of dots in the "O"s in this
 TYPE*face,* as well as the drawn mustache
 give a latin personality to this mark.
Principle Type: Standard Family

95.3
Designer: Karl Schulpig
1927 Germany
Client: Theater-Ausstellung, Magdeburg
 Logo/poster for an exhibition
 The initials form a bold mask TYPE*face*
Principle Type: Standard Family

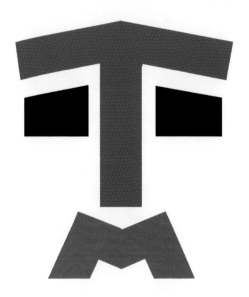

95.1

95.2

95.3

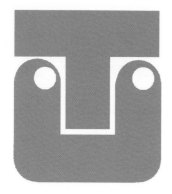

96.1

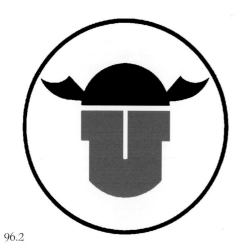

96.2

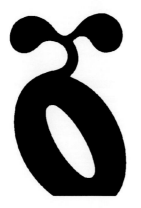

96.3

96.1
Designer: Luigi Montini
1959 Italy
Client: University of Turin
 Student Union Logo
 The initials plus dots for eyes give this
 TYPE*face* portrays a casual school attitude.
Principle Type: Handlettered

96.2
Designer: Hartmuth Pfeil
1926 Germany
Client: Unknown
 Logo for banking services
 The same letters treated somewhat
 differently, gives personality to this TYPE*face.*
Principle Type: Handlettered

96.3
Designer: Tomoko Taketomo
1991 Japan
Client: Tamatsu Okuda
 Personal Mark
 This TYPE*face* is eyes and yawning mouth,
 a blend of Oriental and western letters.
Principle Type: Handlettered

97.1 97.2
Designer: Gerard Dean & Partners
1991 Great Britain
Client: Berthold Typographic Communications Ltd.
 Advertising Illustration
 These grinning TYPE*faces* for a trade ad
 address the idea of high-techno typesetting.
Principle Type: Various

97.3
Designer: Edward A. Saunders
1975 U.S.
Client: Harry H. Otsugi & Associates
 Logo for development consultants
 This TYPE*face* "HO" is two profile faces,
 consulting. The letterforms are fairly obscure.
Principle Type: Handlettered

97.4
Designer: James Sebastian/Designframe Inc.
1990 U.S.
Client: The LS Collection
 Logo
 This TYPE*faces* for a retailer of high-end
 decorative objects is both identity and the
 viewing consumer.
Principle Type: Gothic

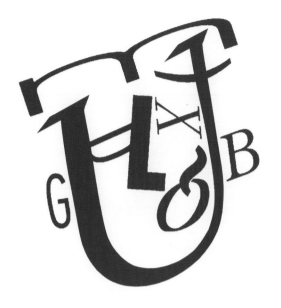

97.1

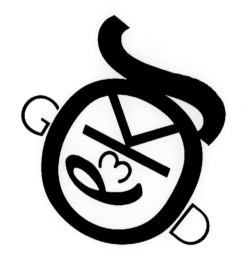

97.2

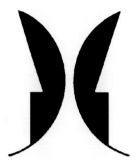

97.3

97.4

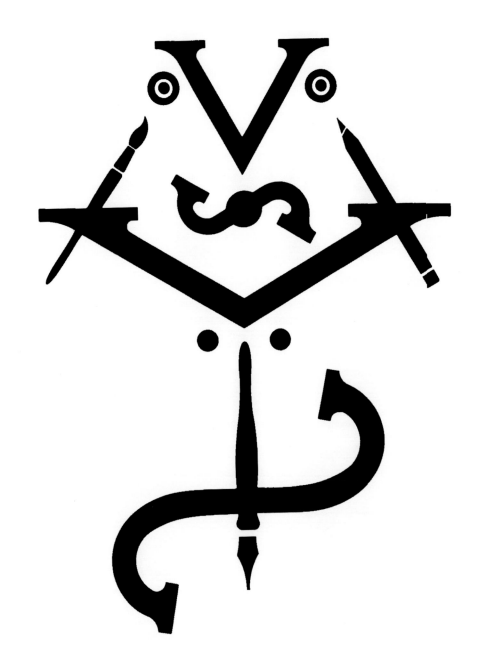

98.1

98.1
Designer: Jay Vigon
AD: Vigon Seireeni
1990 U.S.
Client: Vigon Seireeni
 Promotional studio Icon
 This multiple TYPE*face*, is entitled
 Man Obsessed With V's and S's.
Principle Type: Fortune Family

99.1
Designer: Epinal
1931 France
Client: Societe Anonyme Vosges
 Logo for Cruise Liner
 The TYPE*face* becomes a
 triangle mask.
Principle Type: Handlettered

99.2
Designer: Clive Gardiner
1931 Great Britain
Client: B. Petronzio & Sons
 Logo for a furniture manufacturer
 This triangle TYPE*face* uses the
 company name as hair. The "W"
 makes a wonderful mouth.
Principle Type: Handlettered

99.3
Designer: Alan Anderson
1993 U.S.
Client: Arkea Designer Furniture
 Logo
 The double "A" of this TYPE*face*
 becomes two people, ostensibly the
 designer and the client. Dots are the
 eyes, the "A" crossbars become the
 definition of the noses. The under-
 scores define the chins.
Principle Type: Handlettered

99.1

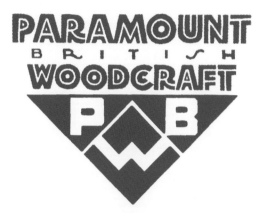

99.2

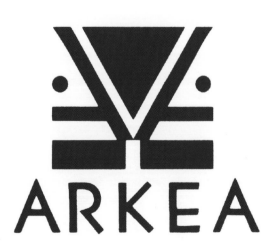

99.3

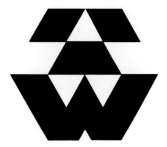

100.1

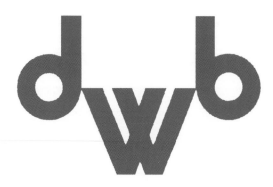

100.2

100.3

100.1
Designer: Gino Bolla
1962 Italy
Client: Unknown
 Logo
 This jack-o-lantern-like TYPE*face*, is
 made from the initials "AW".
Principle Type: Handlettered

100.2
Designer: Max Korner
1948 Germany
Client: Deutscher WerkBund
 Logo for the German Workers Union
 This subtle TYPE*face,* created by the "dWb"
 is interesting in the use of the "W" as
 nose and mouth.
Principle Type: Handlettered

100.3
Designer: Rick Valicente/Thirst
1988 U.S.
Client: Lyric Opera of Chicago
 Logo
 This spare TYPE*face* uses the dot of
 the mouth to make its point and its joke.
 The "O" is the face shape, and the "L" the nose,
 there is no need for eyes.
Principle Type: Optima

101.1
Designer: Neville Brody
1985 Great Britain
Client: *The Face,* magazine No.58
 Logo for an article
 The letters of this TYPE*face* are stretched,
 tilted and turned on their sides to make the
 face. The "E" "O" eyes, and the "P" mouth
 make this an interesting mark.
Principle Type: Handlettered

101.2 101.3
Designer: Jay Vigon
1989 U.S.
Client: LA Design
 Proposed Logos for a Chinese restaurant
 The letters are used to make an Oriental face
 in this TYPE*face* . Especially interesting is the
 "Y" eyes and nose.
Principle Type: Handlettered

101.1

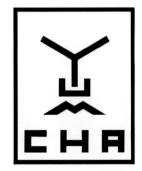

101.2

101.3

102.1
Designer: Rudiger Gotz
AD: Dennis Crowe
1992 U.S.
Client: Zimmermann Crowe Design
Promotional Logo
This Picasso-esque TYPE*face*, is made from the initials "CZ".
Principle Type: Handlettered

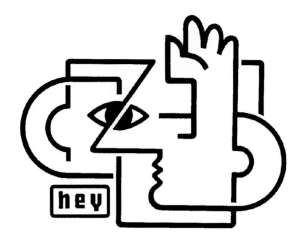

102.2
Designer: Philipp Seitz
1930 Germany
Client: Unknown
Logo
This TYPE*face,* created by the "mZw" has a "Z" nose and eyes, "M" eyebrows and "W" as beard.
Principle Type: Handlettered

102.3
Designer: Mario Eskenazi
1988 Spain
Client: Zoptic
Logo for film and television graphics firm
The negative space to the right of the "Z" defines the nose of this TYPE*face*. The "O" is the eye with parenthesis eyebrow. The mouth, a spellout of the firm name completes the face.
Principle Type: Franklin Condensed

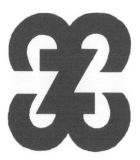

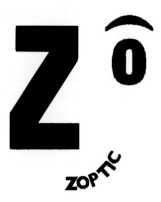

Type that spells out the **TYPE***faces. A special group of icons and symbols that use the letters to make sense as well as a face of the copy. Designed specifically to make a strong statement, these faces are usually short words with dots, type sorts and dingbats sometimes added to make the words work. These clever marks and icons are amusing and memorable solutions to a multitude of logo, poster, packaging, advertising and graphic design problems -*

TYPE THAT
SPELLS OUT THE
TYPE*faces*

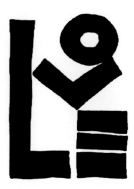

104.1

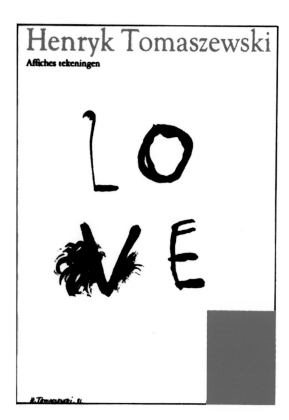

104.2

104.1
Designer: Kurt Kaptur
1991 U.S
Client: B/W Design
 Image for a greeting card
 This familiar word TYPE*face* is an abstracted profile, the "L" is the nose, the "ov" the eye, and the "E" is primitive face marks.
Principle Type: Handlettered

104.2
Designer: Henryk Tomaszewski
1991 Poland
Client: Self
 Promotional poster for a gallery
 A treatment of "love" that is a bold self portrait.
Principle Type: Handlettered

105.1
Designer: Ken Thompson
1991 U.S.
Client: The Los Angeles Gay & Lesbian Community Service Center
 Logo for a fundraising event
 The "O" is an eye, the "U" a nose, and the "t" shorthand borrowed from the comics to indicate a blackened eye for this fundraiser against censorship and homophobia. The word auction is the mouth.
Principle Type: Various

105.2
Designer: John Kane
1992 U.S.
Client: POZ Magazine
 Illustration for an article, *The Face of Aids*
 This becomes a simplified TYPE*face*. The negative spaces are the eyes, and the reversed "s" the mouth.
Principle Type: Futura Extra Bold

105.3
Designer: Marissa Essad
1990 U.S.
Client: Draper & Liew
 Holiday greeting card
 The placement of the type makes a snowman TYPE*face*. The negative "O" becomes the face shape. The "A" becomes a carrot shaped nose, and the agency name becomes a scarf.
Principle Type: Various

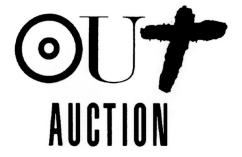

105.1

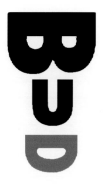

105.4

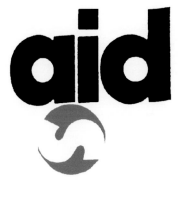

105.2

105.5

105.4
Designer: Bud Lammers
1993 U.S.
Client: Self
 Logo for a photographer
 This simple vertical TYPE*face*,
 is a self-portrait.
Principle Type: Grotesque

105.5
Designer: J. Herbert Carbone
1938 France
Client: Malu
 Logo for a mens' clothier
Principle Type: Handlettered

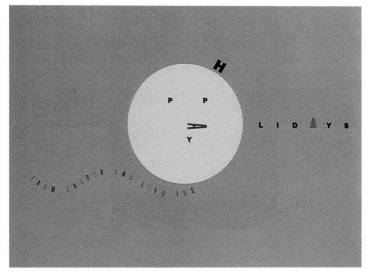

105.3

106.1

EYE N EYE
O
S
E

SMILE

106.2

106.1
Designer: Riki Sethiadi
AD: Philip Gips/Frankfurt Gips Balkind
1989 U.S
Client: Red White & Blue Productions, Inc.
 Logo for an entertainment production company
 This TYPE*face* reversed from a circle is the simplest spellout, shorthand for its' name.
Principle Type: Various

106.2
Designer: Robert Overby
1986 U.S.
Client: Self promotional brochure
 Type illustration
 The words become the features in this distinctive TYPE*face*.
Principle Type: Bodoni

107.1
Designer: Barney Bubbles
1977 Great Britain
Client: Abbey Road Recording Company
 Logo for a rock group
 The elegant placement of type, with an over-sized "L" as the nose, creates a strong personality for this distinctive TYPE*face*.
Principle Type: Handlettered

107.2 107.3 107.4
Designer: Paul Haslip
1989 U.S.
Client: Joel Bernard
 Logo/Identity System for a Photographer
 The playful placement of the letters "j-o-e-l" become a series of TYPE*face* portraits, each with its own distinctive identity.
Principle Type: Various

107.1

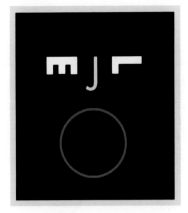

107.2

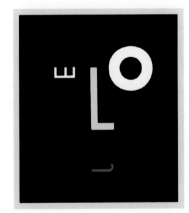

107.3

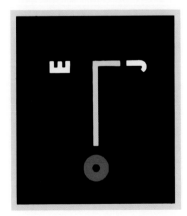

107.4

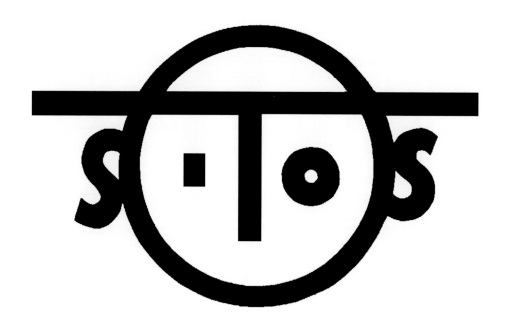

108.1

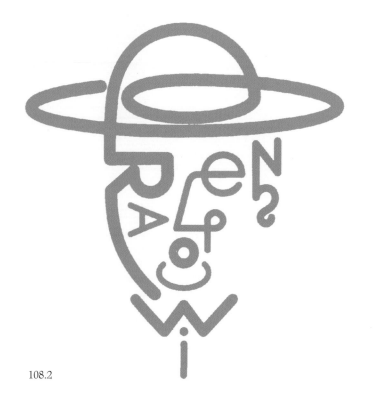

108.2

108.1
Designer: Walter Kersting
1935 Germany
Client: Sitos
 Brand identity for baking and pudding powder
 This winking cleric-like TYPE*face* is an early
 treatment and has a strong personality.
Principle Type: Handlettered

108.2
Designer: Bill Basler
1994 U.S.
Client: Wierman Feed Company
 Brand identity for a farm supplies company
 This TYPE*face* is a pun, a face constructed of
 connected, wire-like type, spelling out the clients
 name. The "M" is a little difficult to find, it is
 either the hat, abstracted, or a repeat of the collar.
Principle Type: Handlettered

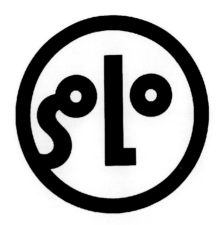

109.1

109.1
Designer: Greg Simpson/The Pushpin Group
1990 U.S.
Client: Solo Editions
 Logo for an agency for illustrators
 photographers and artists reps
 This elegant TYPE*face* is completed by the
 ribbon "S" which attaches to the spectacle "O's.
Principle Type: Handlettered

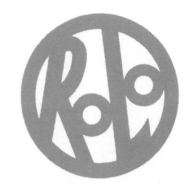

109.2

109.2
Designer: Rodney Chirpe
1949 U.S.
Client: Rolo Manufacturing Co.
 Logo for an oil industry product
 This TYPE*face,* similar to the one above,
 has a more casual attitude. The "R" is hair
 and finishes the face.
Principle Type: Handlettered

109.3
Designer: Carlos Rolando
1990 Spain
Client: Camper
 Icon for a retailer
 The mouth of this TYPE*face* is a *tilda* over
 the "N" in the brand "Otoon". The curl on the
 capital "O" is perhaps the most personable part.
Principle Type: Handlettered

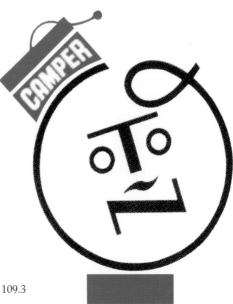

109.3

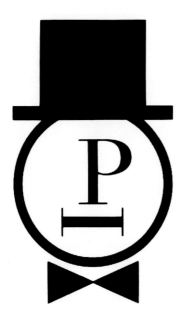

110.1

110.2

110.1
Designer: Ron Kellum
1990 U.S
Client: Topix
 Logo for a computer animation studio
 This TYPE*face,* suggested by the client's name,
 illustrates the letters to become features, top
 hat and bow tie.
Principle Type: Handlettered

110.2
Designer: Rex Peteet
1993 U.S.
Client: Morris & Fellows
 Logo for a shopping center
 The letters of this distinctive TYPE*face* create a
 happy face, with"M" hair and "ro" eye.
Principle Type: Handlettered, Helvetica, Garamond

111.1
Designer: Graham Percy
1964 Great Britain
Client: Face Phototypesetting
 Illustration
 The letters become cartoon TYPE*faces.*
Principle Type: Handlettered

111.2
Designer: W.M. de Majo
1958 Great Britain
Client: John Millar & Sons Ltd.
 Logo for a candy manufacturer
 The links become eyes, mouth and hair,
 the double "ll" the nose in this TYPE*face.*
Principle Type: Handlettered

111.3
Designer: Donna McGuire
AD: Tim Lachowski
1989 U.S.
Client: Michigan State
 State lottery logo
 The "e" and "O" become the eyes,
 the "n" the nose, the diacritical mark mouth
 is neat and the accent eyebrow give this
 TYPE*face* an amused expression.
Principle Type: Handlettered

111.4
Designer: Julie Sebastianelli/ Melanie Bass
1992 U.S.
Client: AIGA/Washington D.C.
 The black face shape defines this TYPE*face,*
 the initials "AIGA" are the features.
Principle Type: Futura, Berkeley, Univers

111.1

111.2

111.4

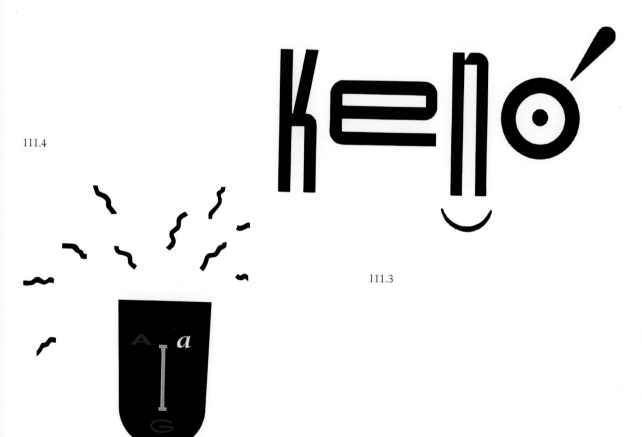

111.3

Hersey

At that time the only illustration soft-ware available was the bitmapped paint program MacPaint. The somewhat crude and unexpected quirkiness of the program was perfect for John's idiosyncratic and inventive style. Although illustration software has grown ever more complex and sophisticated over the years John has explored the latest and most complex aspects of the computer. He has always maintained a sense of play and whimsy, frequently offset by pop iconography and richly colored patterns. His work often has an unsettling edge, as if these odd images were created with a surrealistic Etch-a-Sketch™.

▶ John Hersey was first introduced to the Macintosh computer in 1983 by one of his computer publication clients

> With an international reputation, John has worked on a variety of projects and has done numerous speaking engagements all around the world. John has taught seminars and classes on computer design at Museo Fortuny in Venice, Italy, California College of Arts and Crafts, Kent State, and CalArts.

> John asked the students to use video imagery, both as subject matter and raw material, for an investigation into the myth and the meanings of "the media." The students then processed taped and live video feed images through software programs like Photoshop™, Freehand™ and Swivel 3D™. For most of the students, this was their first illustration problem ever and John got them off to a great start. ◀

112.1
Designer: Sean McKenney
AD: Jeffery Keedy
1993 U.S
Client: California Institute of the Arts
Illustration for *Fast Forward,* **a series of**
student projects on graphic design in the
computer era
This TYPE*face* illustration uses the letters
of "John" as the face, "Hersey" becomes a
spoken headline, and the body copy
literally becomes the body.
Principle Type: Computer Generated

113.1
Designer: Jean Christophe Cribelier
1985 France
Client: Tohan
Logo for a retailer
The clients name becomes a positive/
negative TYPE*face.*
Principle Type: Handlettered

113.1

113.2
Designer: Koji Eto
AD: Setsuko Nishizaki
1988 Japan
Client: Kumamoto Kenmin TV
Logo for a popular music channel
The "Ps" becomes eyes, the "O" nose,
the "MTV" the mouth in this TYPE*face.*
The WORDS "music network" becomes
the hair. The face shape is a "Q" for quality.
Principle Type: Handlettered

113.2

113.3
Designer: David Lemley
1993 U.S.
Client: Makin' Faces
Logo for an alternative rock band
This TYPE*face* is a kind of joke, a name
and mark that won't pigeon-hole the band.
The script "Makin" is hair, the features and
face shape are the word "Faces".
Principle Type: Handlettered

113.3

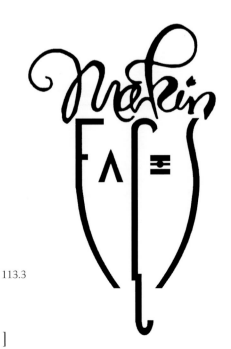

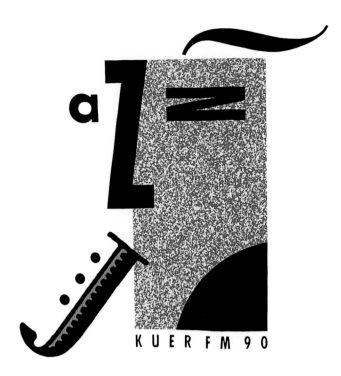

114.1

114.1
Designer: Traci O'Very Covey
1989 U.S
Client: KUER FM90
Jazz promotional logo for a radio station
This illustration TYPE*face* is a portrait of the musician and his instrument.
114.2
Promotional tee shirt for KUER FM
Principle Type: Various

115.1
Designer: Paula Scher
1988 U.S.
Client: Öola
Identity for a chain of Swedish candy stores. Poster
The word "öola" was invented by the designer to sound and look Scandinavian. The umlaut, the mark over the "o," is an eyebrow as well as giving a European look to the identity. The character of the "o" gives it the appearance of eyelashes, the "l" becomes a nose, and the "a" the mouth. The italic character of the type give it an active appearance.

115.2
Logo application to shopping bags.
115.3
Promotional sweatshirt.
Principle Type: Gillies Gothic

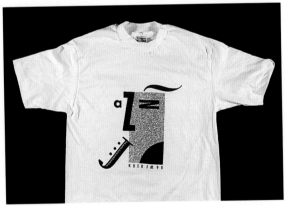

114.2

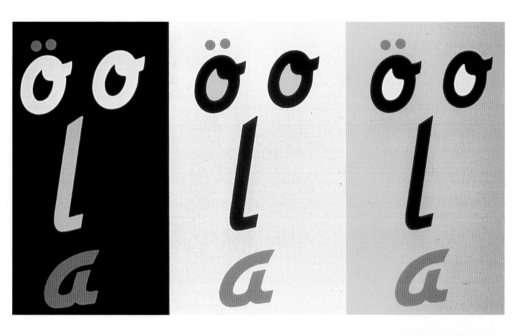

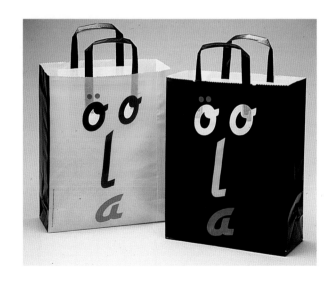

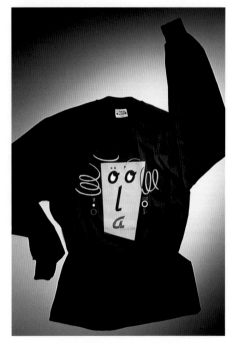

116.1
Designer: David Uerch
AD: Chris Hill
1987 U.S
Client: The Galleria
 Small space ad for a shopping mall
 This TYPE*face,* "TOYS" spells its' message.
Principle Type: Handlettered

116.2
Designer: Lanny Sommese
1991 U.S.
Client: AquaPenn Spring Water
 Identity for a still water
 The letters within the words become face
 and hat within the TYPE*face.*
Principle Type: Futura Family

116.3
Designer: Rebecca Linser
1994 U.S.
Client: I·DEN·TI·TY Magazine
 Illustration for an editorial article
 The "Os" and "U" within the type
 becomes the TYPE*face,* the color defines
 this *Kilroy was here* styled face.

117.1
Designer: Saul Bass/Art Goodman
1960 U.S.
Client: Transparent Papers Ltd.
 Brand Identity for Nylon Stockings
 The script spellout of the initials "TeePee"
 become two TYPE*faces.* The face shapes
 are defined by the package, and the drawing
 on the type gives identity and finishes the face.
Principle Type: Handlettered

117.2
Designer: Gerald Bustamante/Miguel Perez
1991 U.S.
Client: One World, Inc.
 Identity for hair care products
 The "O" and the numeral "1" become the
 features of this TYPE*face.*
Principle Type: Helvetica

117.3
Designer: Herb Lubalin
1967 U.S.
Client: Topps Chewing Gum
 Proposed identity for Bazooka Bubble Gum
 The "Os" and "U" within the type become
 eyes and mouth of this TYPE*face.*
Principle Type: Handlettered

116.1

116.2

116.3

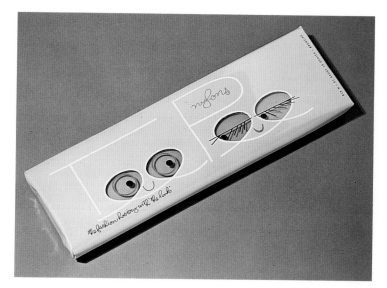

117.1

117.2

117.3

118.1

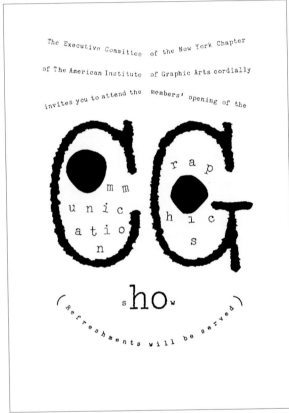

118.2

118.1
Designer: Gustavo Pedroza
1986 Argentina
Client: Documenta
 Logo for a bookstore
 This looking TYPE*face*, a simplified pair of glasses with drawn eyes, gives a strong and sophisticated identity to this shop.
Principle Type: Helvetica

118.2
Designer: Alexander Isley
1989 U.S.
Client: AIGA, New York Chapter
 Illustration for the Communication Graphics exhibitiion opening
 This post card invitation becomes a TYPE*face*. All the copy is part of the face. The lines at the top are hair, the title of the show becomes the eyes, the"ho" of show is the nose, and the curved line in parenthesis the mouth.
Principle Type: Typewriter

119.1
Designer: Richard Smith
1994 U.S.
Client: Multiple Sclerosis Society, Washington
 Logo for a fundraiser - U.G.L.Y. stands for Understanding, Generous, Lovable You
 This acronym TYPE*face* uses the letters as features. The cartoon styling of the type lends an informal quality, echoed in the face shape of this mark.
Principle Type: Handlettered

119.2
Designer: Lana Rigsby
1991 U.S.
Client: Zoot Restaurant
 Logo/Poster for an upscale restaurant
 The stylish placement of the type makes a delightful TYPE*face*. The black ground becomes a face shape and enhances the strong identity.
Principle Type: Futura

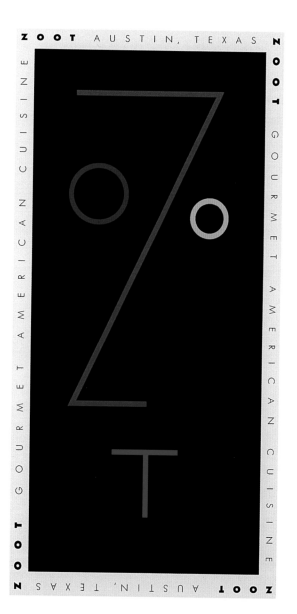

119.2

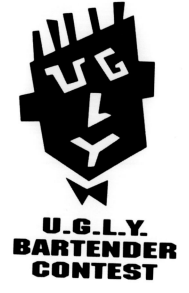

U.G.L.Y.
BARTENDER
CONTEST

119.1

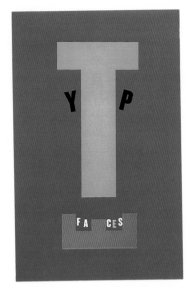

120.1

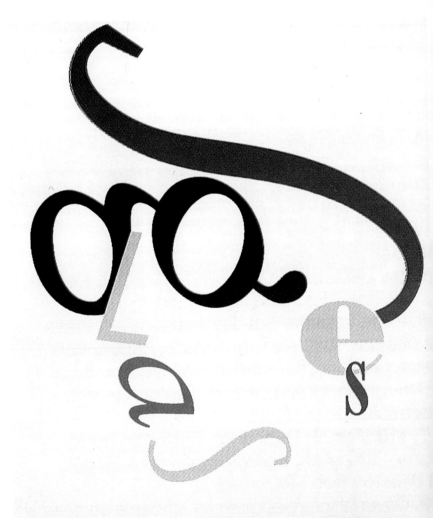

120.2

120.1
Designer: Alexander Isley/David Albertson
1994 U.S
Client: PBC International Inc.
Divider page for the book *American Typeplay*
This expressive TYPE*face* uses the letters
"TYPE" in and out of scale. The letters "FACES"
become snaggly teeth.
Principle Type: Grotesk

120.2
Designer: Paul Hill
Ag: Ice Inc.
1993 U.S.
Client: Bausch & Lomb
Advertisement illustration
TYPE*face* creates a strong personality from the
word "glasses". The use of the lower case "g" as
a pair of glasses is a very nice touch.
Principle Type: Various

121.1 121.2 121.3
Designer: Rick Valicenti/Thirst
1989 U.S.
Client: *In Living Color*
Logo studies for the popular television show
These deconstructed TYPE*faces* force the type
into a series of unusual face shapes. The top
version is almost a screwball cartoon face. The
middle version uses the black ground shape to
define the face. The "O"s and "L" and the
red rule becomes the mouth. The bottom
version becomes an African style mask.
The "O" is the mouth.
Principle Type: Handlettered

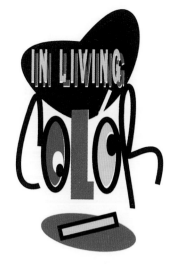

121.1

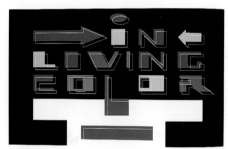

121.2

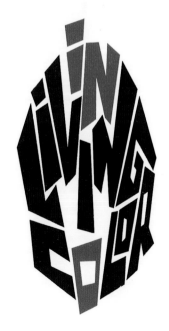

121.3

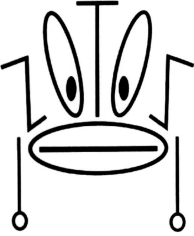

122.1

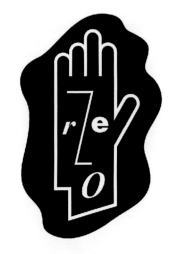

zerolith

122.2

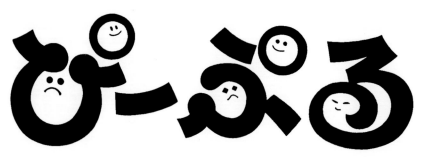

122.3

122.1
Designer: Rick Valicentl/Thirst
1989 U.S
Client: Shiseido
 Proposed Funny Face logo for a
 beauty product
 This TYPE*face* focuses on the word
 "ZOTOS" as an African mask cartoon.
Principle Type: Handlettered

122.2
Designer: Michael Chikamura
1994 U.S.
Client: Zerolith Inc.
 Logo for a prepress firm
 The letters "Zero" become the features
 in this TYPE*face*. The hand is the face
 shape floating on an amoebic black ground.
Principle Type: Various

122.3
Designer: Yasubumi Miyake
1988 Japan
Client: Nagasaki Evening Herald
 Logo for a Newspaper
 The hiragana characters of this TYPE*face*
 spell out the word "people". The addition of
 dots and curves turn the characters into
 pictographs that illustrate the same idea.
Principle Type: Handlettered

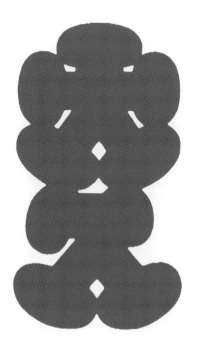

123.1
Designer: Kazumasa Nagai
1985 Japan
Client: Unique & Interesting Kanji
 Book illustration
Using the Kanji characters for "Welcome Crowds", this TYPE*face* spells out an appealing little character to be used in retail stores.
Principle Type: Handlettered

123.2
Designer: Jilly Simons/ Joe VanDerBos
1988 U.S.
Client: Concrete
 Vacation announcement
Using the common "open" and "closed" signs as eyes, this TYPE*face* spells out its message in the curved line that forms the mouth.
Principle Type: Helvetica

123.1

123.2

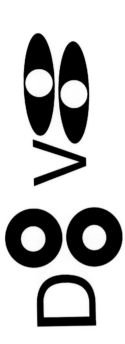

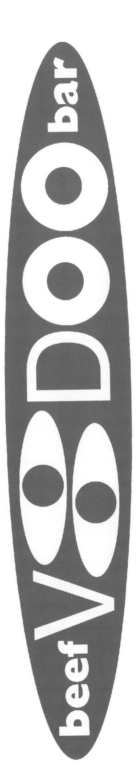

124.1
Designer: Michael Glass
1990 U.S.
Client: Levy Restaurants
 Studies for a Logo for a casual
 restaurant
 These TYPE*faces* combine to form the word VooDoo.

124.2
 Finished logo. This TYPE*face* is two faces contained in a surfboard face shape.
Principle Type: Handlettered

125.1
Designer: Steven Brower
1993 U.S.
Client: Carol Publishing Group
 Book cover
 This jacket illustration TYPE*face* spells out all the cover information and doubles as a portrait of Groucho Marx . The title is hair, the sub-title becomes glasses and mustache, and the authors name becomes his cigar. The bow tie carries the publishing and design credits as well as the price.
Principle Type: Standard Condensed

125.2 125.3
Designer: John McConnell/Martin
Tilley/Pentagram
1987 Great Britain
Client: Face Photosetting Ltd.
 Calendar
 This ongoing project of TYPE*face* illustrations reminds their clients that Face sets type.
Principle Type: Franklin Gothic

125.1

125.2

125.3

126.1
Designer: John Heartfield (Helmut Herzfelde)
1920 Germany
Client: Malik Verlag
 Type illustration for *Der Dada* magazine
 The prototype of the TYPE*face*. A word
 picture from this radical movement.
Principle Type: Woodtype

126.2
Designer: Jane Brady/Sarah Spratt
AD: Ryo Nakagawa
1992 U.S. / Japan
Client: Izumiya Corporation
 Logo for a retail operation
 The "O"s become the eyes and the
 rule becomes a mouth. The company,
 called .Too, uses alternate logos inter-
 changeably in their materials although
 this seems to be the logo of choice.
Principle Type: Handlettered

126.3
Designer: Paula Scher
1988 U.S.
Client: Simon & Schuster
 Book cover
 The title "Uncommon Wisdom"
 plus assorted dashed rules, dots and bars
 make this TYPE*face*. "Uncommon" is an
 eyebrow, "Wisdom" is the mouth.
Principle Type: Futura Light

126.1

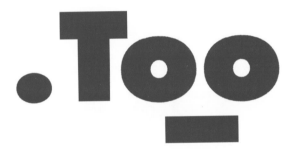

126.2

126.3

TYPEfaces where the type has been modified or abstracted. This group of icons and symbols alter not only the shapes of the letters, but the meaning as well. This special group of abstracted **TYPE**faces create multiple meanings from one simple image. There are not many, but these are very special symbols -

ABSTRACTED
TYPEfaces

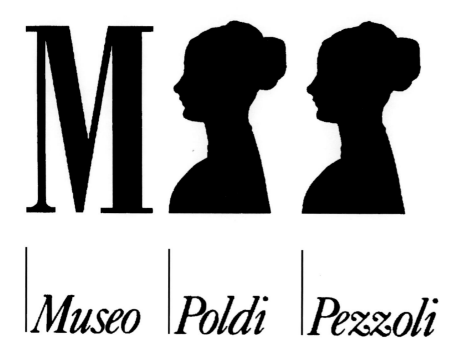

Museo *Poldi* *Pezzoli*

128.1

128.1
Designer: Italo Lupi
1983 Italy
Client: Poldi Museum
 Symbol for the museum
 in Pezzoli
 The "P"s become
silhouette portraits of the
founders of the collection.
This iconographic
typography TYPE*face,* is
a powerful and direct
method of communication.
Principle Type:
 Garamond Condensed

129.1
Designer: Seymour Chwast
AD: Harris Lewine
1968 U.S.
Client: MacMillan
 Book Jacket
 Image and type is
combined in this
TYPE*face.* The "D"
becomes the silhouette
of Roosevelt. This design
relies on the viewers
knowledge of the symbols,
both that the initials
"FDR" stand for Franklin
Delano Roosevelt and
that the illustration is
the President.
Principle Type:
 Franklin Gothic

FDR:

Architect of an Era
by Rexford G. Tugwell
his friend and advisor

129.1

130.1
Designer: Ernie Smith
1975 U.S.
Client: Public Broadcasting Service
 Logo
 The "P" becomes the viewer. This silhouette TYPE*face* presents a human quality. Image and type are combined in this TYPE*face*. The circle eye is repeated as the negative counters in the other letters.
Principle Type: Handlettered

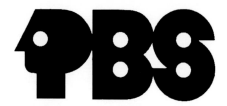

130.1

130.2
Designer: Tom Geismar
1984 U.S.
Client: Public Broadcasting Service
 Logo
 The "P" is flopped and shadowed to update this mark. The shape becomes the audience.
 Principle Type: Stymie Family

130.3
Designer: James Cabral
AG: Young & Rubicam
1993 U.S.
Client: Melon Head Design
 Logo
 The "O" of this mark becomes a birds-eye view of the head shape. The slightly hydrocephalic head of this TYPE*face* is meant to suggest "big ideas".
Principle Type: Sabon

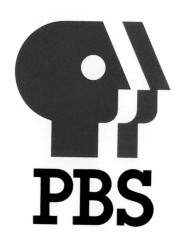

130.2

131.1
Designer: Milton Glaser
1970 U.S.
Client: K & F Productions
 Concert poster
 The "B"s become dynamic icons of the musicians.
Principle Type: Handlettered

130.3

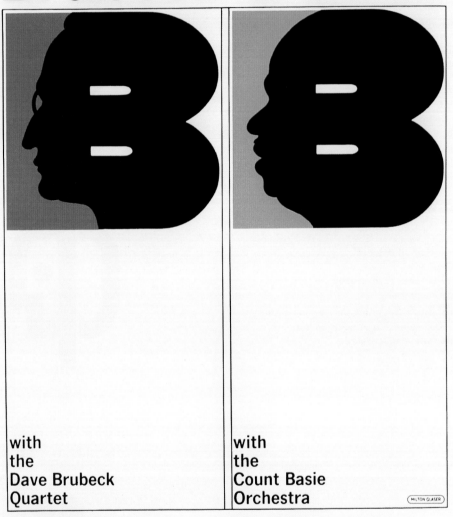

K & F Productions Presents

Brubeck & Basie

with
the
Dave Brubeck
Quartet

with
the
Count Basie
Orchestra

MILTON GLASER

Exclusive Columbia Recording Artist

Exclusive Verve Recording Artist

Oct 18th, 8:30 Tickets: $5.50, 5.00, 4.50, 4.00, 3.50
Lincoln Center Philharmonic Hall

Tickets on sale now at Lincoln Center. Mail Orders: K & F Productions 120 E. 30 St. LE 2-2080

131.1

132.1

Designer: Philipp Seitz

1932 Germany

Client: Oxei

Logo for an egg farm

This cartoon character TYPE*face* becomes
the happy customer. The "O" doubles as
an egg shape and the mouth appears to be the
yolk with a bite taken from it.

Principle Type: Handlettered

132.2

Designer: F. Everett Forbes

1969 U.S.

Client: Computer Profiles, Inc.

Logo

The "P" is redrawn to become the profile.
The negative shape becomes the "P" as well.
The "C" is the back of the head and the
stem of the "P" the neck of this TYPE*face*.

Principle Type: Handlettered

132.3

Designer: Helmut Schmidt

1979 Germany

Client: Grafischer Fachverband

Logo for a printer

The unfinished "G" becomes a mouth, the
dot eyes become the printing rollers.

Principle Type: Handlettered

132.1

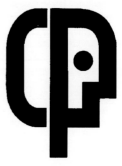

132.2

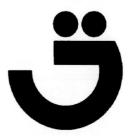

132.3

Handwritten **TYPE**faces. A unique group of symbols and icons that use pen or brush to give an expressive quality and casual immediacy to logos, packages, illustrations and editorial copy. The hand drawn letters permit the freedom to alter letterforms to make the face a particular statement. These drawings allow the designer to make pictographs of any word, a primitive word picture, a hieroglyph, as well as a face -

HANDWRITTEN
TYPEfaces

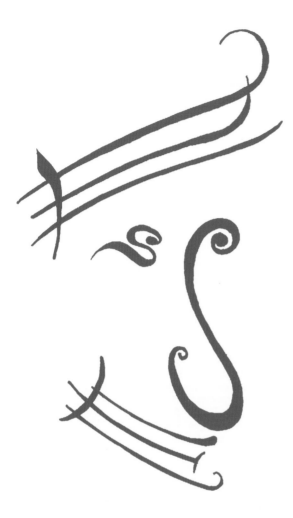

134.1

134.1
Designer: Kathy Mercky
1991 U.S.
Client: Gilbert Paper
 Illustration for a paper promotion
This TYPE*face* character becomes a happy recycler. The "Es" are hair and mouth, the "Ss" become nose and eyes. A very casual illustration designed as an emboss.
Principle Type: Handlettered

135.1
Designer: Nancy Yeasting
1991 Canada
Client: Nancy Yeasting
 Self promotional signature illustration
The eyes are the initials "N" and "Y", the nose and mouth ar the initials "D" and "I" for design and illustration. This TYPE*face* can be modified for holiday promotions, a Santa hat makes it a Christmas promotion, and so forth.
Principle Type: Handlettered

135.2
Designer: Sonsoles Llorens
1989 Spain
Client: City of Marseille
 Symbol for an arts festival
The initials "B,J,C" become the features and the "M" becomes the highlight in the hair. The addition of the dot to the eye gives a focus to this TYPE*face.*
Principle Type: Handlettered

135.3
Designer: Maureen Erbe
1989 U.S.
Client: Los Angeles Music Center
 ***Thank God its Friday* symbol for free noon concerts at the performing arts center**
This cartoon TYPE*face* becomes the happy concertgoer. The initials "TGIF" are the features. The "F" mouth and the spiral "G" are particularly nice.
Principle Type: Handlettered

135.4
Designer: Scott Thares
1991 U.S.
Client: Scott Thares Design
 Logo for a design studio
The letters of Scott Thares' name spells this casual TYPE*face.*
Principle Type: Handlettered

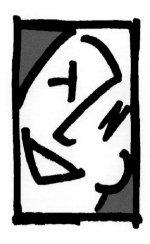

135.1

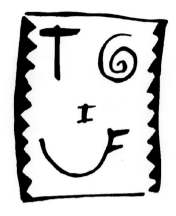

135.3

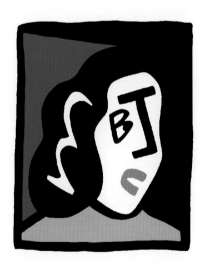

BIENNALE DES JEUNES
CREATEURS D'EUROPE
DE LA MÉDITERRANÉE

135.2

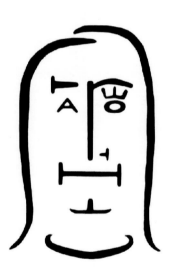

135.4

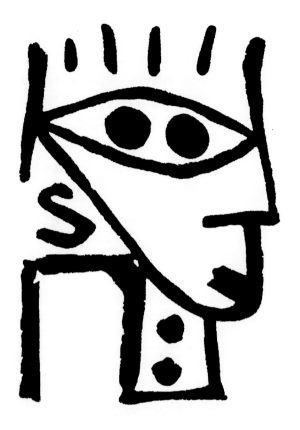

136.1

136.1
Designer: Paul Klee
1928 Germany
Client: Kings Absolute
 Illustration for a Bauhaus publication
 This cartoon character TYPE*face* spells the
 title of this article. The "K" is the mask, the
 "I" punctuation above the mask is hair, the
 "N" shape is the shoulder, The "G" is the
 face shape and the "S" decoration.
Principle Type: Handlettered

137.1
Designer: Pablo Picasso
1955 France
Client: Madura Pottery
 Poster for a ceramics exhibition at Vallauris
 The "XPO" become the features and the
 double "L" in Vallauris become legs and feet
 beneath this TYPE*face.*
Principle Type: Handlettered

137.2
Designer: Todd Waterbury
AD: Joe Duffy
1990 U.S.
Client: Restaurant Associates
 Logo for a French fast-food restaurant
 The letters become the features in this
 portrait of Toulouse-Lautrec. The upside
 down "U" as a derby is a nice touch.
Principle Type: Handlettered

137.3
Designer: Doug Zimmerman/Rick John
1993 U.S.
Client: Doug Zimmerman Illustration
 Logo for an illustrator
 The letters "doug Z" makes a self portrait
 of this TYPE*face.*
Principle Type: Handlettered

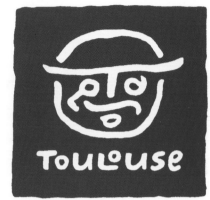

137.2

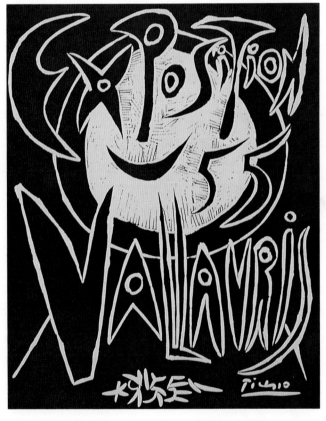

137.1

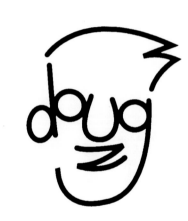

137.3

MALIBU

138.1

MADAME TUSSAUD'S

138.2

Sonja

138.3

138.1
Designer: Jay Vigon
AD: Vigon Seireeni
1990 U.S.
Client: Jimmy'z
 Proposed symbol for a line of clothing, *Malibu Dudes*
 This cartoon character TYPE*face* spells out
 its very casual face, with equally casual lettering.
Principle Type: Handlettered

138.2
Designer: John Harris
1986 Great Britain
Client: Madame Tussaud's Waxworks
 Logo
 The type is redrawn to become the symbol
 for this entertainment venue. The cartoon
 quality of the mark somewhat relieves the grim
 reality of the Waxworks.
Principle Type: Handlettered

138.3
Designer: Robert Valentine
1987 U.S.
Client: Sonia Kashuk Hair & Makeup
 Identity for a beautician
 The crayon crude drawing of her name gives
 a strong identification to this TYPE*face*. The
 "S" becomes a rather crooked nose.
Principle Type: Handlettered

139.1
Designer: John Lennon
AD: Bill Brown/Vahe Fattal
1991 U.S.
Client: Warner Brothers
 Symbol for film and record promotion
 This cartoon spellout TYPE*face* is the personal
 monogram of the Beatle.
Principle Type: Handlettered

139.1

140.1
Designer: Dennis Landry
1992 U.S.
Client: ABG Management
 Logo for a rock group
 A smile-y sun TYPE*face*. The word "IS", the
 name of the group become the eyes.
 Principle Type: Handlettered

140.2
Designer: Unknown
1954 U.S.
Client: O & S Bearing & Manufacturing Co.
 Logo
 This casual TYPE*face,* quite typical for its period,
 has become popular today, for its naive retro quality.
 Principle Type: Handlettered

140.3
Designer: Margo Chase
1993 U.S.
Client: Miriam Bogan
 Logo for a fashion stylist
 The sunglasses "B" under the "M" hair becomes
 the personification of the stylist.
 Principle Type: Handlettered

141.1
Designer: Rolando Baldini/Vania Vecchi
1973 Italy
Client: Circolo di Cinematografica
 Logo for a film club
 This TYPE*face* uses the features of Charles
 Chaplin to create a strong identity. The "C" eyes,
 though subtle, are the initials of the club as well
 as the actor.
 Principle Type: Handlettered

140.1

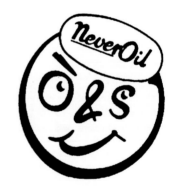

140.2

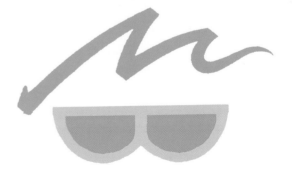

140.3

141.1

142.1
Designer: Miraslav Jiranek
1989 Czechoslovakia
Client: Czech Civic Forum
 Symbol for the revolutionary movement that
 helped restore democracy to Czechoslavakia
This simple cartoon TYPE*face* becomes the happy
citizen. The "O" is the simplest letter/figure.
Principle Type: Handlettered

142.2
Designer: Antonio Klinz
1960 Italy
Client: Mondadori
 Symbol for a publisher's promotion
The "A-Z" is the TYPE*face*. The casual attitude of
this illustration is an indication of the style of the
children's publication it is promoting.
Principle Type: Handlettered

142.3
Designer: Michael Patrick Cronan
1992 U.S.
Client: California College of Arts & Crafts
 Icon for a viewbook
A sophisticated TYPE*face*, the large "C" becomes
the face shape, the "A" becomes the mouth, nose
and chin, and the small "c"s the eyes.
Principle Type: Handlettered

143.1
Designer: Shuichi Suzuki
Ag: Dentsu, Inc.
1992 Japan
Client: Idex Corporation
 Identity for a television station, World Entertainment
This TYPE*face* is a blend of casual cartoon and
corporate Japan, it becomes a strong identity.
Principle Type: Handlettered

143.2
Designer: Bryan L. Peterson
1990 U.S.
Client: AIGA, Dallas
 Logo for the 75th Anniversary
The anniversary logo becomes the face of the
graphic design professional.
Principle Type: Handlettered

143.3
Designer: Dicken Castro
1979 Colombia
Client: Olga Lucia Jordon
 Logo for a photographer
The letters reversed from film become personable.
Principle Type: Handlettered

142.1

142.2

142.3

143.1

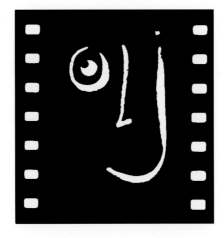

143.2

143.3

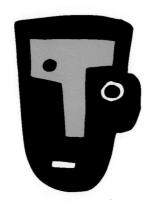

144.1

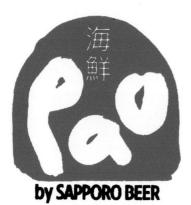

144.2

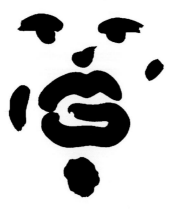

144.3

144.1
Designer: Kathy Warriner
1992 U.S.
Client: Tropo Music
 Logo for a music production company
 This "T" TYPE*face* represents an interest
in the music of other cultures.
Principle Type: Handlettered

144.2
Designer: Masaaki Takafume/ Kusagayai Hiromura
1989 Japan
Client: Sapporo Beer
 Brand Identification for a restaurant
 The "P O" become eyes and the "a" the
nose of this TYPE*face*. The line under
the shape acts as the mouth.
Principle Type: Handlettered

144.3
Designer: Jay Vigon
AD: Vigon Seireeni
1984 U.S.
Client: Gotcha Sportswear
 Alternate Logo
 The "G" becomes a mouth, the rest
of the face is drawn.
Principle Type: Handlettered

145.1
Designer: Tony Lane
1983 U.S.
Client: CBS Records
 Logo for a music group
 This cartoon character TYPE*face* becomes the
musicians. The "O" are eyes, the second "T"
acts as nose and eyebrow. The mouth is a
drawn slash.
Principle Type: Handlettered

145.2
Designer: Unknown
1995 Great Britain
Client: Cameron Mitchell Productions
 Logo for a London musical production
 The word "Oliver" becomes the eyes, nose and
ear in this portrait of the star of the show,
Fagin. The addition of a drawn beard and hat
complete the TYPE*face*.
Principle Type: Handlettered

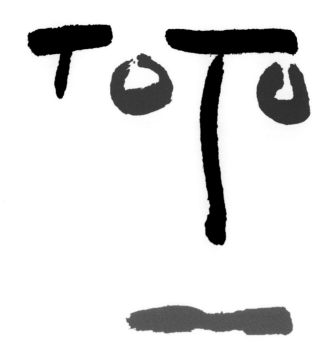

145.1

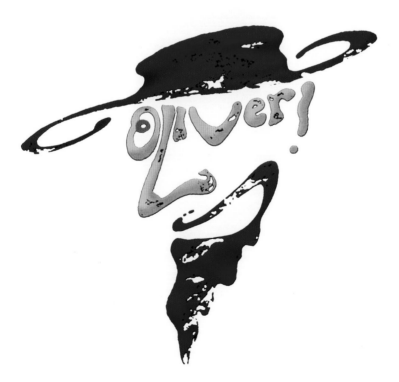

145.2

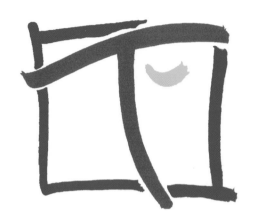

146.1

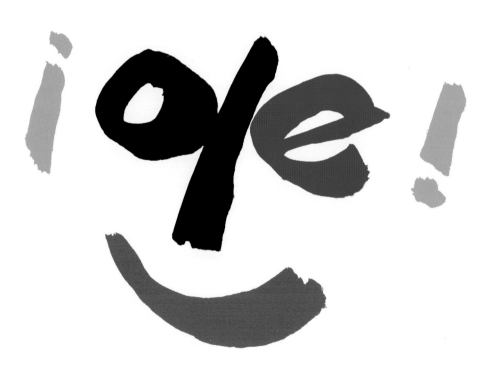

146.2

146.1
Designer: Phil Fisher
1988 Great Britain
Client: T-shirtery
 Brand identity for a package
 This cartoon character TYPE*face*
 becomes an identity that makes
 customers smile. With a minimum
 of information and a \minimum
 of detail, the mark appears
 to be blushing. Also shown package
 design for retail sales.
Principle Type: Handlettered

146.2 147.1
Designer: Gerry Rosentswieg
1995 U.S.
Client: Cantina Concepts
 Logo for a Mexican restaurant
 This series of studies for a TYPE*face*
 logo uses the diacritical marks of
 Spanish to enhance the meaning and
 the look of these marks.
Principle Type: Handlettered

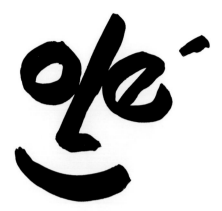

147.1

147.2
Designer: Sharon K. Hanley
1987 U.S.
Client: Lutz T-shirt Printing
 Logo
 The "L" becomes the nose in profile
 of this TYPE*face*. Each of the letters
 act as a feature, the "T" as eyebrow
 and/or hair.
Principle Type: Handlettered

147.2

147.3
Designer: John Heiden
1987 U.S.
Client: Music Distributors
 Logo for promotional compact disc
 The copy "pro CD" spell out the face.
 The "R" as nose and mustache is a fine
 use of the letter. "CD" becomes a
 mouth with teeth.
Principle Type: Handlettered

147.3

148.1

MELBOURNE SPOLETO FESTIVAL

148.2

148.3

148.1
Designer: Ken Cato
1990 Australia
Client: Melbourne International Arts Festival
 Logo for the Melbourne Spoleto Festival
 This elegant TYPE*face*, with a minimum
 of detail provides the festival with a strong
 identity. The painted "S" as nose and the
 varicolored dots as eyes make the oval shape
 a complete face, interchangeable as performer
 or audience for this ever-changing event.
 Also shown, two years of posters for the event.
Principle Type: Handlettered

149.1
Designer: Roger Labon Jackson
1969 U.S.
Client: "Are You Experienced," Inc.
 Illustration for a T-shirt
 The copy on this shirt spells out the songs
 of Jimi Hendrix, and the afro spells out his
 name. A classic TYPE*face*.
Principle Type: Handlettered

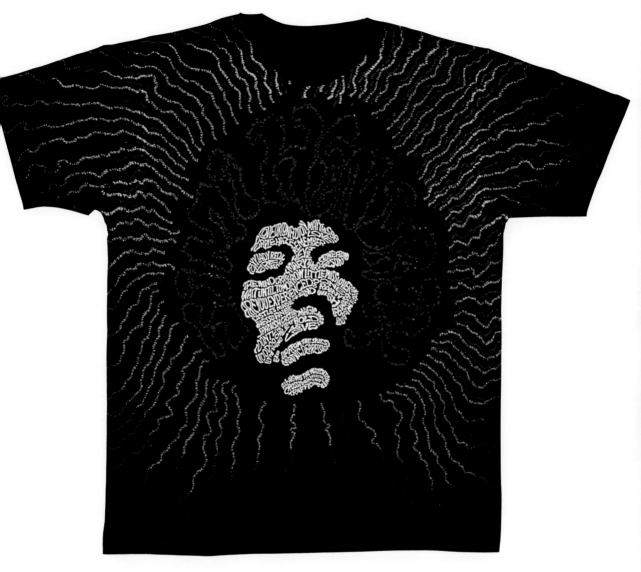

149.1

RACISM [3]

150.1

CIMUS

150.2

150.1
Designer: James Victore
1994 U.S.
Client: Brno International
Biennale
 Poster
This strong illustration
TYPE*face* was the winner
of the ICOGRADA Grand
Prix Award. The letters
become the eating and eaten
and the scary mouth makes
a strong statement about
the subject.
Principle Type: Handlettered

150.2
Designer: Robert Burns
1982 Canada
Client: Comus Music Theatre
 Logo
The singing letters spell out
this TYPE*face*.
Principle Type: Handlettered

151.1
Designer: Rick Valicenti
1991 U.S.
Client: Gilbert paper
 Illustration for a paper
 promotion
The letters of this TYPE*face*
become a popular epithet.
Principle Type: Handlettered

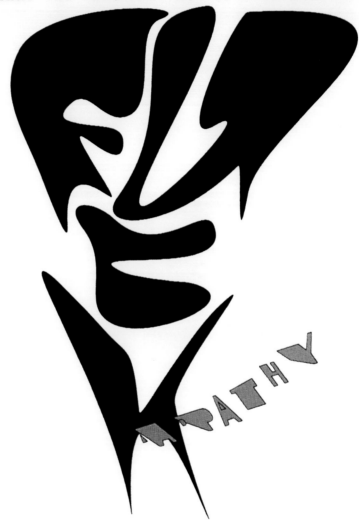

151.1

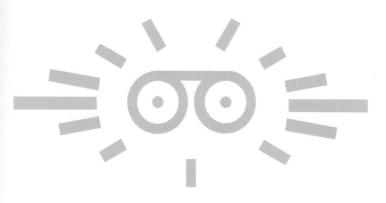

152.1

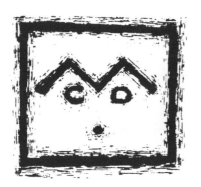

152.2

152.1
Designer: Unknown
1994 Russia
Client: Moscow International Poster Biennale
 Logo for an exposition
This looking TYPE*face* becomes the viewer in this poster competition. The Golden Bee as the exhibition is known, lends itself to this treatment of an abstracted "B".
Principle Type: Handlettered

152.2
Designer: Margo Chase
1990 U.S.
Client: Margo Chase Design
 Logo
The "M" becomes eyebrows for the "C D" eyes. The TYPE*face* in its rectangular face shape give a hand hewn quality to this artist who is known for her computer work.
Principle Type: Handlettered

TYPE*faces created from symbols or numbers, or both. The letterforms of numbers are used not only for their subjective content but for their shapes as well. The faces created from symbols are similar, though the contextual meanings are not as strong. A unique group of icons and symbols that push the boundaries of picture and content. These marks make expressive images primarily for editorial ideas and illustration.*

N U M B E R S
O R
S Y M B O L S
TYPE*faces*

154.1

154.1
Designer: Ken Cato
1990 Australia
Client: Graphic-Sha Publishing Group
Book Cover
This TYPE*face* symbol for a book
containing the favorite works of the
world's leading graphic designers is
appropriately looking at the viewer. The
Roman numeral I becomes face frame,
nose and mouth.
Principle Type: Handlettered

155.1 155.2 155.3 155.4
Designer:Gerry Rosentswieg
1989 U.S.
Client:The Graphics Studio
 Studies for icons for fifth anniversary
 of offices in Hollywood
The "5" becomes face frame, nose
and mouth, with commas, periods
and "O"s as the eyes..
Principle Type: Various

155.5
Designer: Jean Page
1964 Great Britain
Client: Robert Meyer Design Group
 Self promotion brochure
This chapter heading becomes
a TYPE*face*. The "T" defines the
face shape and is the nose, the "W"
with the addition of dots become
eyes, The "O" tilted on its side
is the mouth.
Principle Type: Various

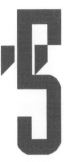

155.1

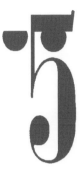

155.3

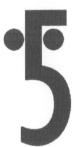

155.2

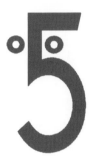

155.4

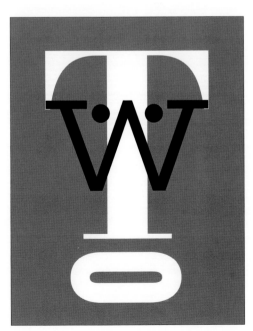

155.5

156.1
Designer: Carlos Segura
1988 U.S.
Client: Kindergarten - 7
 Logo for a primary school
 The "K" becomes the defining face shape
 in this TYPE*face*, and acts as the nose. The 7
 is a boundary and hair. . The planet shaped eye
 and the smiling mouth complete the face.
Principle Type: Handlettered

156.2
Designer: Gerry Rosentswieg
1989 U.S.
Client: Sherman Oaks Community Hospital
 Icon for a brochure
 The number "19" becomes a TYPE*face*
 the negative space becomes an eye, and the
 same shape is repeated for the mouth.
Principle Type: Handlettered

157.1
Designer: Woody Pirtle
1985 U.S.
Client: KTXH -TV
 Television station logo
 The clever overlap in channel 20's logo
 is all that is needed to create a TYPE*face*.
Principle Type: Handlettered

157.2
Designer: Greg Valdez
1993 U.S.
Client: Hoechst Celanese
 Logo for a convention
 The numbers with the addition of dots
 become a TYPE*face*.
Principle Type: Garamond Family

157.3
Designer: Ron Kellum/Beverly McClain
1985 U.S.
Client: Eye to Eye Creative Solutions, Inc.
 Logo
 This rebus TYPE*face* is a visual pun. It reads
 as a linear sequence and a pictogram.
Principle Type: Helvetica

157.4
Designer: Masayuki Watanabi
1989 Japan
Client: Japan Charity Association
 Campaign logo
 The "22"s provide a frame for the TYPE*face*.
Principle Type: Handlettered

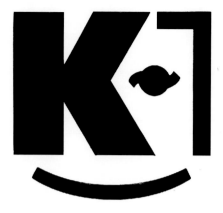

156.1

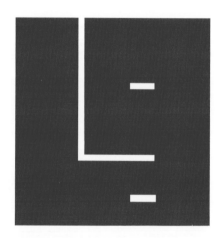

156.2

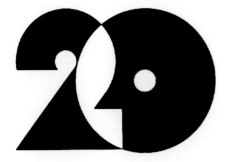

157.1

20/20

157.2

157.3

157.4

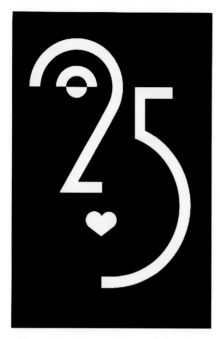

158.1

158.1
Designer: Rex Peteet
1987 U.S.
Client: Mary Kay Cosmetics
 Anniversary logo
 This TYPE*face* is a play on positive/negative, the heart provides a feminine touch in this neatly defined mark.
Principle Type: Handlettered

159.1
Designer: David Suter
1995 U.S.
Client: The New York Times
 Editorial illustration
 The "50" becomes face and reflection in this TYPE*face*. The illustration, for the personal health section of the Times refers to breast self-examination for women over 50 years of age.
Principle Type: Handlettered

159.2
Designer: Gerry Rosentswieg
1986 U.S.
Client: NuMed
 Symbol for anniversary
 This TYPE*face* celebrates *30 years of helping people*. The "3" defines the brow, nose and jaw, and the "0" tilted to the angle of the "3" becomes the eye.
Principle Type: Peignot

159.3
Designer: George Vogt
1994 U.S.
Client: Fox/KPDX
 Logo for a television station
 These numbers combine to make a TYPE*face*. The "4" becomes the nose in profile and the tail of the "9" becomes the mouth, the bowl of the "9" acts as the eye with a period as the pupil.
Principle Type: Hand lettered

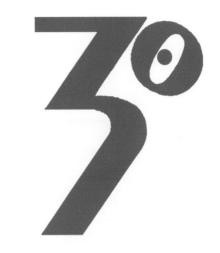

159.2

159.1

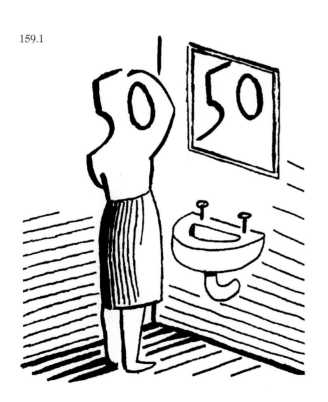

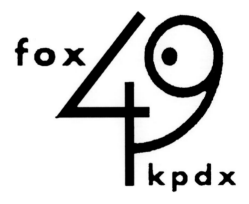

159.3

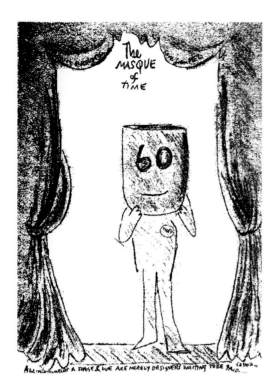

160.1

160.1
Designer: Mel Calman
1989 Great Britain
Client: Pentagram
　Illustrated greetings for a birthday book
　This TYPE*face*, part of the celebration of Pentagram partner, Theo Crosby's 60th birthday, refers to Crosby's mask collection. This pencil drawing has an additional message under the figure " All th worlds a stage & we are merely designers waiting to be paid.
Principle Type: Peignot

160.2
Designer: Lanny Sommese
1988 U.S.
Client: Penn State Glee Club
　Logo for the group's centennial
　These numbers act as the eyes of this TYPE*face*. The "C", for centennial mouth has a sound bite arrow pointing to the future.
Principle Type: Harpers

161.1
Designer: John Clark
1993 U.S.
Client: Looking
　Editorial page from promotional brochure
　The numbers "66", with the addition of dots as pupils, become the eyes of this TYPE*face*. The "S" is the nose and the "Ave"becomes the mouth.
Principle Type: Lithos

160.2

On the occasion of

Yr·
at
66°
S·
Ave
2'

161.1

162.1
Designer: Jackie Foshang
AD: Kit Hinrichs/ Pentagram
1994 U.S.
Client: San Francisco 2000
 Event logo
 The first two numbers "20" in the
 sequence "2000" make the features
 of this TYPE*face*. The second set of
 zeros almost becomes a second face.
Principle Type: Handlettered

162.2
Designer: Ken Thompson
1990 U.S.
Client: Being Alive
 Advertisement illustration
 The TYPE*face* "1000" creates a strong
 personality for this ad. The backslant of
 the numbers illustrates that the
 organization will bend over backwards
 and give 1000 percent.
Principle Type: Raleigh Gothic

163.1
Designer: Terry Allen
AD: Lucy Bartholomay
1991 U.S.
Client: *Boston Globe Magazine*
 Sunday supplement magazine cover
 This illustration TYPE*face* uses the "9"
 as a telephone, and the "O"s as eyes in
 this clever rendition. The lead article is
 about the proliferation of 900
 telephone numbers.
Principle Type: Handlettered

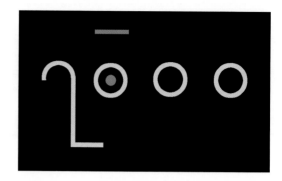

162.1

162.2

163.1

TYPE*faces created from multiple numbers*

164.1

164.2

164.1
Designer: J. Weinzetel
1953 Czechoslovakia
Client: Solo Linik
 Illustration for a match box
 The numbers "2x1" are the focus, and become the eyes for this TYPE*face,* the "X" becomes the mouth and the "?" is an ear.
Principle Type: Handlettered

164.2
Designer: Michael Wolff/Robert Maude
1993 Great Britain
St: Addison Corp. Annual Reports, Inc
Client: Addison Worldwide, Ltd.
 Self promotional brochure
 The numbers are used to create faces, they are distorted, flopped and spun so that they make not only features, but chins and foreheads. The figures used are somewhat forced in this TYPE*face.*
Principle Type: Various

165.1
Designer: Jeff Pollard
AG: Williams & House
1992 U.S.
Client: Engraved Stationery
Manufacturers Association
 Brochure illustration
 The TYPE*face* "Image, Value, Numbers, Face", a strong image made by combining numbers. The results, a face where "7"s become nose, face shape and chin and "6"s the eyes.
Principle Type: Various Serif Faces
165.2
Brochure cover

165.3
Designer: Arne Andersen
1960 Denmark
Client: Regnskabs Automation A/S
 Advertisement for accounting machinery
 This TYPE*face* illustration uses arabic numerals as the shapes in this figure. The use of the "8" as the eyes, and the "7" braids with "8" bows are especially inventive.
Principle Type: Various

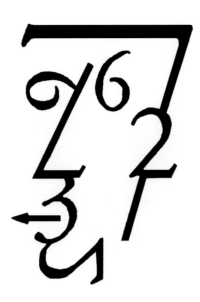

165.1 165.2

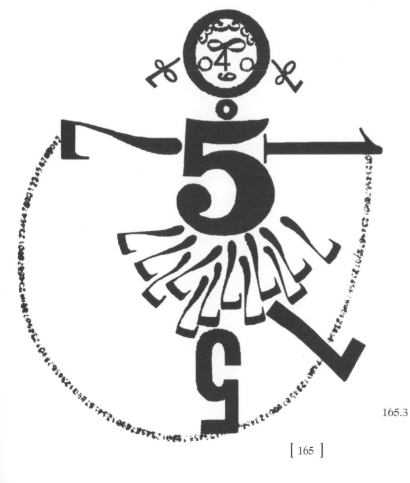

165.3

TYPE*faces created* *from Number Counters*

166.1
Designer: Barbara Gendler Soll
1984 U.S.
Client: Art Direction Book Company
 Book jacket design
 The word "Creativity" becomes hair
 in this TYPE*face,* and the hash-mark
 counters are the eyes and nose. The
 sub-head type line is the mouth.
Principle Type: Handlettered

167.1
Designer: Grapus
1981 France
Client: Architecture & Justice
 Magazine cover
 The hash-mark counters are all the
 features in this TYPE*face.*
Principle Type: Helvetica/handlettered

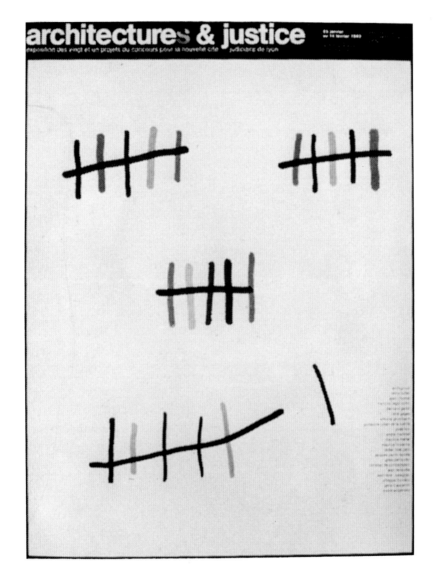

167.1

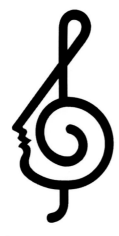

168.1

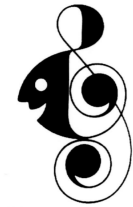

168.2

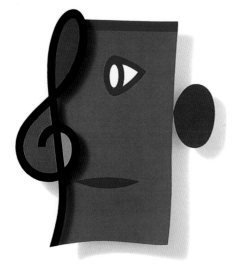

168.3

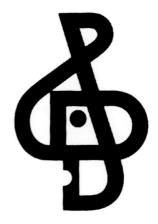

168.4

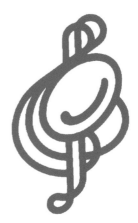

168.5

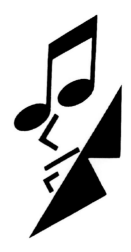

168.6

168.1
Designer: Gerry Rosentswieg
1974 U.S.
Client: Young Musicians Foundation
 Logo
 The musical clef with the addition
 of a profile becomes a TYPE*face*.
Principle Type: Handlettered

168.2
Designer: Gerald Reis
1970 U.S.
Client: Young Audiences of the Bay Area
 Logo
 The treble clef becomes nose/profile/ear
 in this illustration TYPE*face*.
Principle Type: Handlettered

168.3
Designer: Iku Akiyama
1984 Japan
Client: Music Magazine
 Magazine cover illustration
 The treble clef becomes a nose in this TYPE*face*.
Principle Type: Handlettered

168.4
Designer: Othmar Motter
1975 Austria
Client: Bregenz Festival
 Music festival logo
 The treble clef combined with a "B" makes
 a lively TYPE*face* for a music festival.
Principle Type: Handlettered

168.5
Designer: Nikola Nikolov
1980 Bulgaria
Client: Bulgarian State Television
 Channel O logo
 The happy face O echoes the treble clef shape
 making a lively TYPE*face* identity for TV.
Principle Type: Handlettered

168.6
Designer: Thomas di Paolo
1991 Germany
Client: Bill's Music and Comics
 Logo
 This TYPE*face* is spelled out with notes as eyes,
 and the letters becoming the other features.
Principle Type: Handlettered

169.1
Designer: Kazumi Nakamura
1990 Japan
Client: Okada Music School
 Logo
 A child's face is defined by a musical note
 within the initial "O" in this TYPE*face*.
Principle Type: Handlettered

TYPE*faces created* *from Music Symbols*

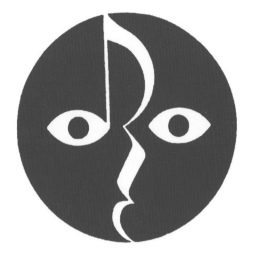

169.1

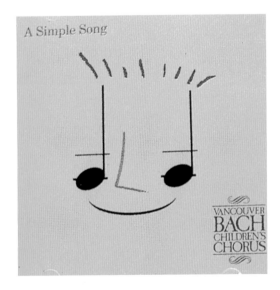

169.2

170.1
Designer: Yoshio Hayakawa
1976 Japan
Client: Isora Cosmetics Company
 Logo
 Three dots and an "I" create a
 TYPE*face,* the perfect symbol for
 a cosmetic company .
Principle Type : Handlettered

170.2
Designer: Yoshio Hayakawa
1952 Japan
Client: G-Sen Confectionary
 Logo for a sweet shop
 As above, the two dots become eyes and
 the exclamation point is nose and mouth.
 A symbol TYPE*face* to entice people to
 come in and enjoy sweets.
Principle Type: Handlettered

170.3
Designer: David Bullock
1978 U.S.
Client: Gordon Dickinson & Co.
 Accountants logo
 This TYPE*face·* made from the
 multiplication and division symbols
 gives a lighthearted personality to a
 normally conservative business.
Principle Type: Handlettered

171.1
Designer: Michael Cousins
1988 U.S.
Client: Charles Gomez, CPA
 Accountants logo
 The TYPE*face* for this accountant
 is made up of a plus and minus as
 eyes, an abstracted square route symbol
 as the nose and an equal sign for the
 mouth. Altogether a superb mark
Principle Type : Handlettered

171.2
Designer: John and Barbara Casado
1980 U.S.
Client: University of California at
Los Angeles Extension
 Logo for continuing education
 The infinity symbol combined with two
 profiles makes an apt TYPE*face*
 illustrating the concept of continuous
 and continuing education .
Principle Type: Handlettered

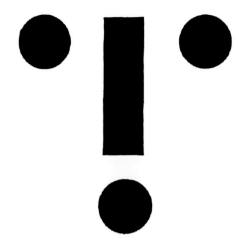

170.1

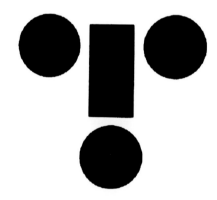

170.2

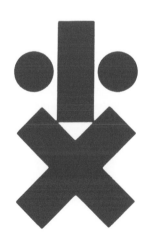

170.3

TYPE*faces created from Punctuation and Type Symbols*

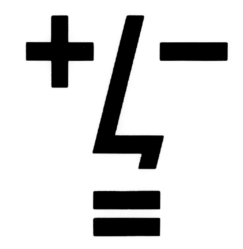

171.1

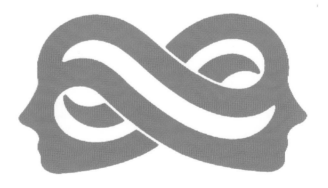

171.2

172.1
Designer: Kristin Sommese
1993 U.S.
Client: Pennsylvania State University
Panhellenic Council
 Logo for a series of educational programs
 A heart and the male symbol are the
 prominent features in this TYPE*face*.
Principle Type: Futura Bold and Senator Tall

172.2
Designer: Ikko Tanaka
1988 Japan
Client: Executive Committee of the
International Festival of Theatre of Tokyo
 Theatre festival logo
 This TYPE*face* is made of negative and
 positive triangles. The resulting mask
 becomes a fitting symbol for theatre.
Principle Type: Handlettered

173.1
Designer: Misae Uchida
AD: Takayuki Uchida/Yoshikatsu Yanagimoto
1986 Japan
Client: Tsutamori Dental Clinic
 Logo
 This TYPE*face*·made from elementary shapes
 depict the mouths of patients at this children's
 dental clinic. Used either vertically or horizontally
 the shapes become a distinctive logo.
173.2
 The shapes are used interchangeably and with
 the addition of simple features become symbols
 for a crying face, open mouth, open wider and
 the happy face.
Principle Type: Handlettered

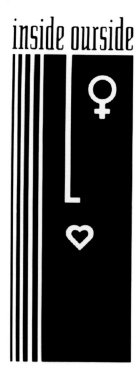

172.1

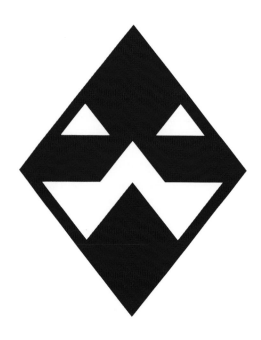

172.2

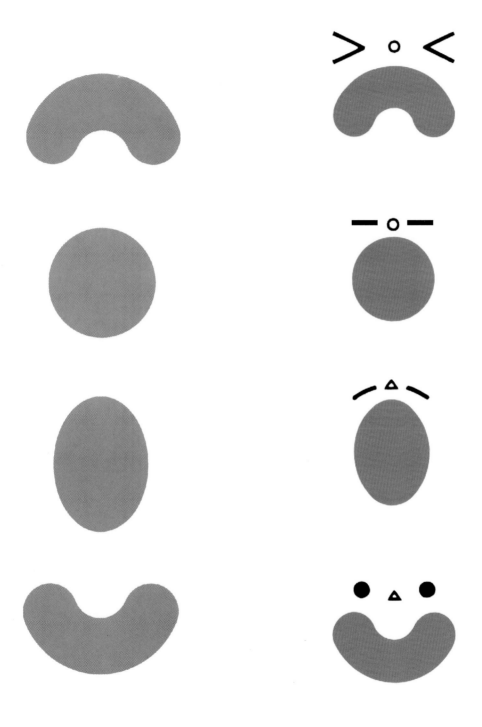

173.1 173.2

174.1

174.1
Designer: Robert Shelley
1977 U.S.
Client: Television Station WMAR
 Logo for the CBS Late Movie
 The well-known CBS logo at half
 mast becomes the eyes in this TYPE*face.*
Principle Type: Handlettered

175.1
Designer: John McConnell/Pentagram
1980 Great Britain
Client: Face Typographers
 Promotional Calendar
 The shapes, lozenges and dot, create a
 robot TYPE*face.* In addition, the grommets
 and rotating discs which are the ears,
 make this a functioning daily calendar.
Principle Type: Standard

175.2
Designer: John McConnell/Pentagram
1980 Great Britain
Client: Face Typographers
 Promotional Calendar Illustration
 This TYPE*face.* portrait of Laurel and
 Hardy is an exercise in reducing the
 elements of an image to the minimum,
 and yet leave it recognizable.
Principle Type: Type Sorts

175.3
Designer: Paul Rand
1984 U.S.
Client: Yale University Press
 Illustration
 A caricature of Hitler/Groucho? The
 TYPE*face* is constructed from two squares,
 three rules and two dots. Recognition of
 this reductionist illustration is based on
 prior knowledge.
Principle Type: Handlettered

175.2

175.1

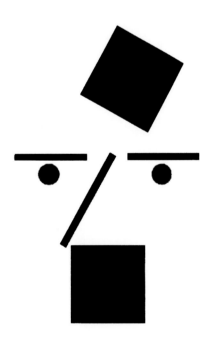

175.3

176.1
Designer: Doug Akagi/Sherri Brooks
1984 U.S.
Client: California College of Arts and Crafts
 Poster for an art school conference
 Punctuation marks become features
 in this TYPE*face*. The title, *Concept 84*
 becomes a rakish hairdo, quotation marks
 the eyes, exclamation mark the nose and
 the body copy the mouth.
Principle Type: Alternate Gothic No. 1

176.2
Designer: John McConnell/Pentagram
1981 Great Britain
Client: Face Typographers
 Promotional Calendar Illustration
 Shapes that make this reductionist
 TYPE*face*, two dots and two squares become
 eyes, nose and mouth.

177.1 175.2 175.3 175.4
Designer: John McConnell/Pentagram
1979 Great Britain
Client: Face Typographers
 Promotional Calendar Illustration
 These TYPE*faces* are created from
 punctuation marks, each illustration
 echoing the mnemonic *face* made from
 typography. The copyright symbol as a
 mouth, quotation marks as fangs, greater
 than and less than symbols as grin lines,
 and an upside-down exclamation mark
 as a swollen eye and a tear.
Principle Type: Various

177.5
Designer: Rob Hugel
1983 U.S.
Client: Herman Miller Inc.
 Advertisement illustration
 The punctuation portrait in this ad
 for a public affairs program sponsored
 by the client illustrates the concept
 Participation requires information.
 This TYPE*face* has quotation mark eyes
 and exclamation mark nose and mouth.
 The same elements are used in 176.1
 though the results are quite different.

176.1

176.2

177.1

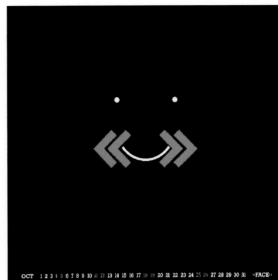

177.2

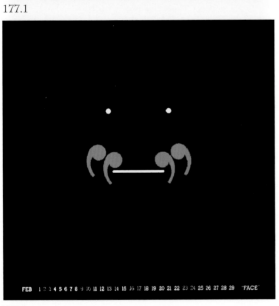

177.3

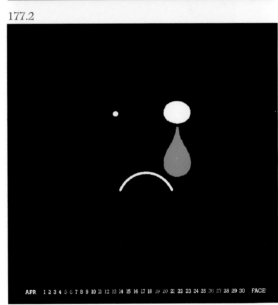

177.4

177.5

178.1

178.2

178.1
Designer: John Clark
1992 U.S.
Client: Looking
 Self-promotional brochure illustration
 Two dots become features in this
 TYPE*face*. The copy line "Look!¡ooꟲ",
 becomes the mouth, the entire page
 is the face shape.
Principle Type: Gill Sans

178.2
Designer: Bruno Monguzzi
1981 Italy
Client: Arti Grafichi Nidasio, Milan
 Brochure illustration
 This punctuation portrait in a
 brochure for Milanese products is
 made from quotation mark eyes and
 question mark nose. The Dot under
 the "?"acts as the mouth.
Principle Type: Didot Bold

179.1
Designer: Michael Fry
1994 U.S.
Client: United Features Syndicate
 Cartoon
 These TYPE*faces* are constructed from
 keyboard characters (punctuation,) they
 are most commonly found on electronic
 bulletin boards and e-mail systems to
 communicate the spirit of the message.
Principle Type: Computer

179.2
Designer: Seth Godin
1994 U.S.
Client: Online Communications
 Book jacket
 Constructed from keyboard characters
 (punctuation,) the TYPE*face* on the
 cover of this book is one of two hundred
 TYPE*faces* called "smileys"by the author.
 Included in this collection are portraits
 of Elvis Presley, David Letterman and
 even Annette Funicello.
Principle Type: Computer

179.1

179.2

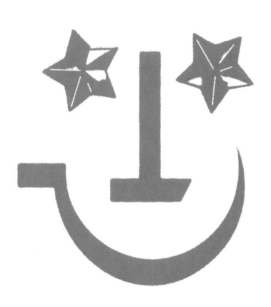

180.1

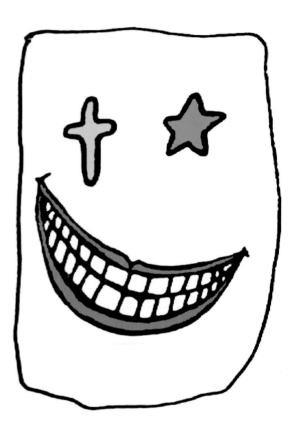

180.2

180.1
Designer: Samuel Kuo
1992 U.S.
Client: Glad-nost!
Logo
Two stars become eyes in this TYPE*face*. The hammer and sickle symbols of Russia become nose and mouth in this clever icon.
Principle Type: Handlettered

180.2
Designer: Tony Palladino
1978 U.S.
Client: Julian Barry
Signature illustration for the
play *Lenny*
This TYPE*face* icon uses religious symbols as eyes in this abstract portrait of Lenny Bruce. The happy mouth is ironic as the symbol for this tragic play.
Principle Type: Handlettered

181.1
Designer: Ronn Campisi
1987 U.S.
Client: Boston Globe
Cover illustration for the Christmas
issue of the Sunday Supplement
This TYPE*face* uses the star as face shape. The rainbow shape acts as neck and costume.
Principle Type: Handlettered

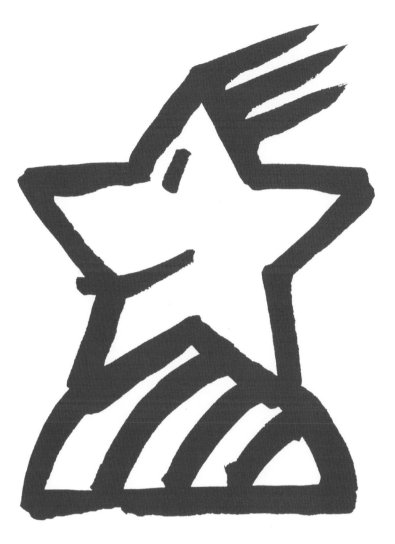

181.1

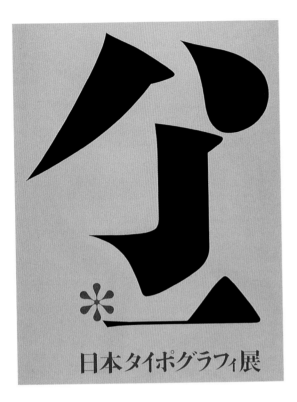

182.1

182.1
Designer: Hiromu Hara
1982 Japan
Client: Japan Advertising Artists Club
 Poster *Element of Kanji*

This Japanese character becomes a TYPE*face* in this poster for an exhibition of typography. The line of body copy at the bottom of the poster is a straggly beard. The letterform is a combination of parts- elements of Japanese characters.

Principle Type: Handlettered

182.2
Designer: Hiroshi Akita
AD: Ikko Tanaka
1986 Japan
Client: Morisawa & Company
 Poster for a typesetting company

This Japanese TYPE*face* character appears to be a nose, eye and traditional Noh eyebrow. The part that appears is only a portion of the character.

Principle Type: Handlettered

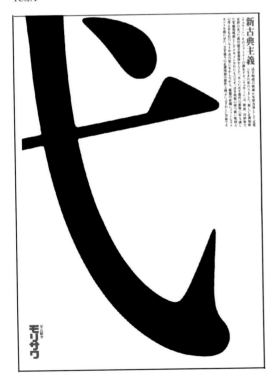

182.2

TYPE*face animals, birds or beast. This series of icons is used as signage, for logos, on posters and as illustrations in children's books. Animals are memorable and easily recognizable, making them good symbols for demarking specific areas. Used for their emotional content, as well as their form, animal* **TYPE***faces explore all the possibilities of the letterform, characters and punctuation. A unique group of icons and symbols that push the boundaries of picture and content. These marks make expressive images -*

ANIMAL
TYPE*faces*

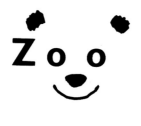 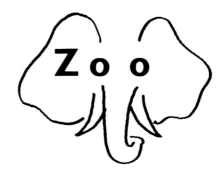 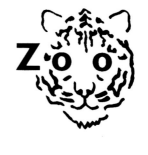

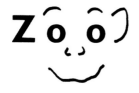 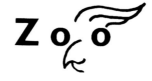 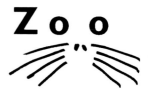

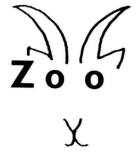 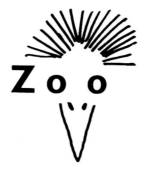

184.1

184.1
Designer: Ian Glazer
AD: Brian Tattersfield
AG: Minale Tattersfield & Partners
1968 Great Britain
Client: London Zoo
 Signage and symbols
 This system of symbols is drawn from
 primitive art. The word "zoo" is the unifying
 element in these TYPE*faces*. The animals
 shown are (first row) panda, elephant, tiger
 (second row) monkey, parrot , walrus (third
 row) antelope, ostrich and giraffe.
Principle Type: Univers

185.1
Designer: Scott Ray
St: Peterson & Company
1990 U.S.
Client: Dallas Zoological Society
 Logo for a zoo
 This TYPE*face* incorporates the characteristics
 of the eyes of beasts and birds, as the "O"s
 in the word "zoo". The center counter of the
 "Z" becomes both the beak of a bird as well
 as a beasts mouth or whisker..
Principle Type: Handlettered

185.2
Designer: Brian Barclay
AD: David Bartels
Ill: Alex Murawski
St: Bartels & Company
1992 U.S.
Client: Saint Louis Forest Park
 Logo for a zoo
 The eyes, "O"s of an unidentifiable animal
 peer out from behind a "Z" in this
 TYPE*face*. The patterning on the"Z" also
 implies the markings of some wonderful
 wild animal.
Principle Type: Handlettered

185.1

185.2

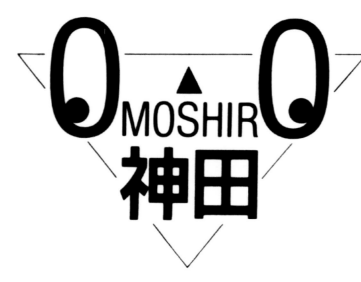

186.1

186.1
Designer: Hiroyuki Shiwatari
AD: Masahiro Miyazaki
1987 Japan
Client: Shirane Group
 Icon for a newsletter column
 This TYPE*face* indicates the liveliness
 of the Kanda district. Omoshire is the
 name of the corespondent. The first and
 final "O" of his name become the slightly
 wall-eyed seeing eyes of a night animal.
 The Japanese characters become the
 mouth which spell out the subject of the
 article. The triangle background becomes
 the face shape.
Principle Type: San Serif Condensed

187.1
Designer: Brian Barclay
AD: David Bartels
St: Bartels & Company
1991 U.S.
Client: NRG Corps
 Logo for a T-shirt wholesaler
 This logo plays with the viewer, the
 TYPE*face* is the face of some wonderful
 creature, perhaps hanging upside down
 from a tree like a sloth. This amusing
 beast becomes the perfect vender of
 casual clothes.
Principle Type: Handlettered

187.2
Designer: Tony Hyun
AD: Gerry Rosentswieg
St: The Graphics Studio
1990 U.S.
Client: Society for the Prevention of
Cruelty to Animals, Los Angeles
 Proposed logo
 The undefined animal eyes makes
 each letter into a different creature.
Principle Type: Bodoni

187.3
Designer: Alexander Calder
1963 U.S.
 Pictogram
 Cat is drawn as a TYPE*face,* each
 letter a different part of the animal.
 I am not quite sure what part of the
 cat the "T" is supposed to be.
Principle Type: Handlettered

JUST NOOIT!

187.1

SPCÄ

187.2

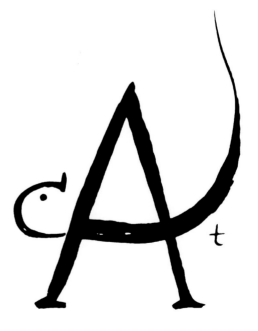

187.3

188.1
Designer: Mike Salisbury
1993 U.S.
Client: Gotcha
 Logo for a product line
 This simplified cat-shaped face is the background
 for this TYPE*face*. The "O", "C" and "A" become
 eyes and mouth of this distinctive mark.
Principle Type: Anzeigen grotesk/ handlettered

188.2
Designer: Bill Gardner
St: Gardner-Greteman-Mikulecky
1988 U.S.
Client: Wichita Cat Hospital
 Logo
 This TYPE*face* logo is both the symbol for care,
 the cross, and the patient, the cat.
Principle Type: Handlettered

189.1
Designer: Kinue Yonezawa
AD: Katsu Asano
1989 Japan
Client: Morel, Japan
 Logo
 This cat TYPE*face* is for a manufacturer of
 eyeglass frames. The negative space of the "M"
 defines the shape of the cat's face.
Principle Type: Handlettered

189.2
Designer: Glen Tsutomu
1991 Japan
Client: Makoto Animal Hospital
 Logo for a veterinarian
 The casually lettered "M" becomes a cat TYPE*face*
 with whiskers, the points of the "M" are ears and
 the swash of the "M" becomes the cat's tongue.
Principle Type: Handlettered

189.3
Designer: Petrula Vrontikis
1992 U.S.
Client: Barker & Young
 Logo for a public relations firm
 The combination of "B" and "M" becomes a cat
 TYPE*face*, the line separating the letters defines
 the eyes and ears, the + sign becomes a mouth.
Principle Type: Handlettered and Modula

189.4
Designer: Inju Sturgeon
1994 U.S.
 Event Logo
 The treble clef becomes a cat TYPE*face* with the
 addition of whiskers and ears.
Principle Type: Handlettered

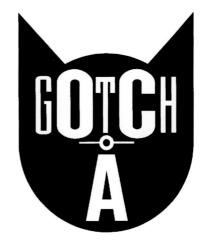

188.1

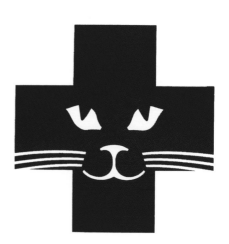

188.2

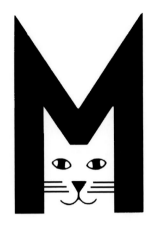

189.1

BARKER YOUNG

189.3

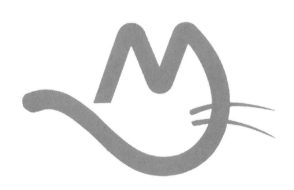

189.2

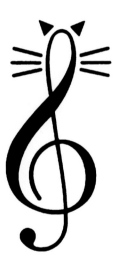

189.4

190.1

190.1
Designer: Don Sibley
St: Sibley/Peteet Design
1990 U.S.
Client: Weyerhauser
 Identity icon for a paper manufacturer
 This TYPE*face*, Jaguar, is spelled out.
 Each letter becomes a part of the jaguar
 face. The soft "U" as the nose is well
 chosen. The addition of whisker rules
 completes the face.
Principle Type: Various

191.1
Designer: Fred Woodward/Anita Karl
AD: Fred Woodward
1994 U.S.
Client: Rolling Stone Magazine
 Editorial Illustration
 The word "Meow" becomes a TYPE*face*.
 The "M" become ears, the script "E", with
 the addition of swash whiskers is the nose,
 the "W" becomes a bow on the cat's collar.
Principle Type: Various/handlettered

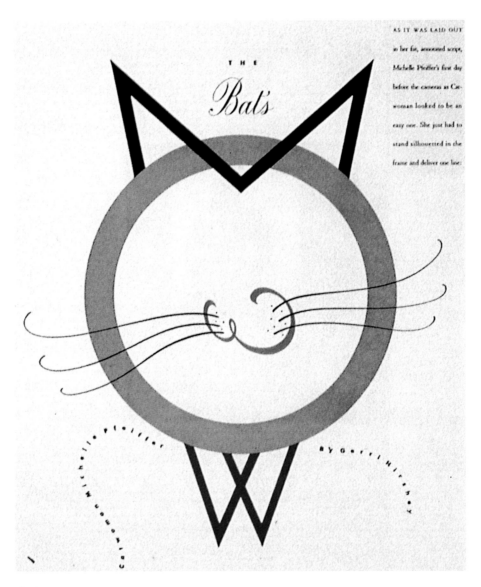

THE *Bat's* M O W

CATWOMAN Michelle Pfeiffer BY Gerri Hirshey

191.1

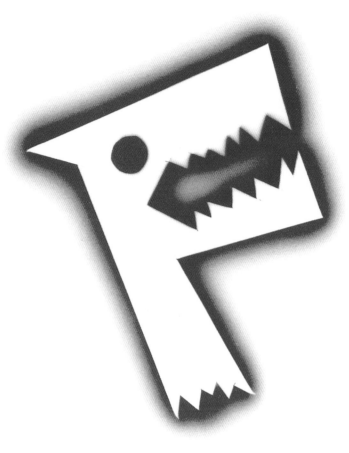

192.1

192.1
Designer: Jay Vigon
AD: Kim Champagne
St: Vigon Seireeni
1990 U.S.
Client: Warner Bros Records
 Proposed logo
 This TYPE*face*, for the rock musical
 group, *Fahrenheit*, is a stencilled "F". The
 hand-drawn quality give the mark a
 special immediacy.
Principle Type: Handlettered

193.1
Designer: Frank Varela
1995 U.S.
Client: Zoe
 Personal mark
 The word "ZOE" becomes a TYPE*face*.
 The top arm of the "Z" becomes ears, and
 the bottom arm, the muzzle of this type
 portrait of a Schnauser. The "O" is the
 nose and the "E" becomes an eyelashed eye.
Principle Type: Handlettered

193.2
Designer: Aimee Hucek
1987 U.S.
Client: Yamamoto Moss
 Animal retail products logo
 The negative space of this initial "S"
 becomes the face shapes of a dog and cat
 in this TYPE*face*.
Principle Type: Handlettered

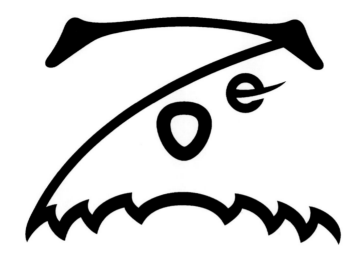

193.1

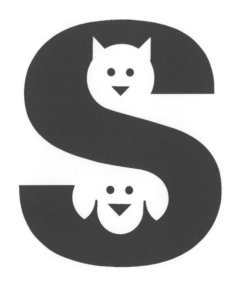

193.2

Rabbit

194.1

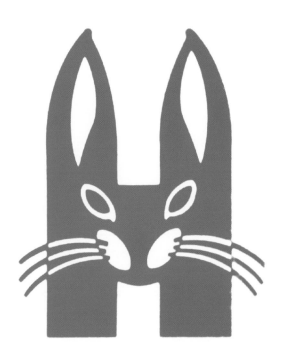

194.2

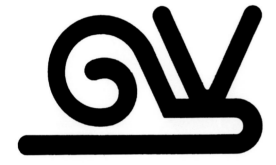

195.2

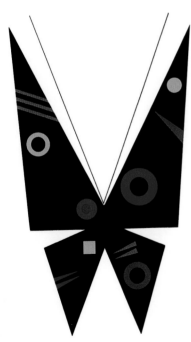

195.1

195.3

194.1
Designer: Kotaro Hirano
1987 Japan
Client: Sony
 Walkman logo
 This TYPE*face* uses the "b"s in
 the word "Rabbit" as rabbit faces.
Principle Type: Handlettered

194.2
Designer: Craig Frazier
ST: Frazier Design
1991 U.S.
Client: Design Realization
 Children's book illustration
 This TYPE*face* "H" *is for hare,*
 happy to hop. The body of the
 letter becomes the face and the
 ascenders become the ears.
Principle Type: Handlettered

195.1
Designer: Dave Kottler/Paul Caldera
ST: Kottler Caldera Group
1994 U.S.
Client: Frogskin
 Logo for a manufacturer of
 amphibious clothing
 The "o" and the bowl of the "g"
 become eyes, and the "g" descen-
 der defines a frog TYPE*face*.
Principle Type: Fenice/handlettered

195.2
Designer: Ricardo Blanco
1974 Argentina
Client: Guido Venier
 Logo for a manufacturer of
 children's furniture
 The "G" and "V" combine to
 create a snail in this sleekly
 modern TYPE*face*.
Principle Type: Handlettered

195.3
Designer: Ikko Tanaka
1989 Japan
Client: Hanae Mori
 Logo for a manufacturer of
 women's clothing
 This butterfly's wings are a
 combination of the "H" and "M"
 initials in this elegant TYPE*face*.
Principle Type: Handlettered

196.1
**Designer: Seymour Chwast
1978 U.S.
Client: Pushpin Studio
 Self-promotional illustration**

This TYPE*face* alphabet, "Beastial Bold" was originally published in the "Not Quite Human" issue of the *PushPin Graphic*. The letters are used from time to time as an embellishment for Chwast's illustrations. Each character has its own particular animal ghoulishness.

197.1 197.2

Example of an ad for a *Frankfurter Allgemeine* newspaper supplement, in 1989, and a detail of the headline "Keine Anschluss".

Principle Type: Handlettered

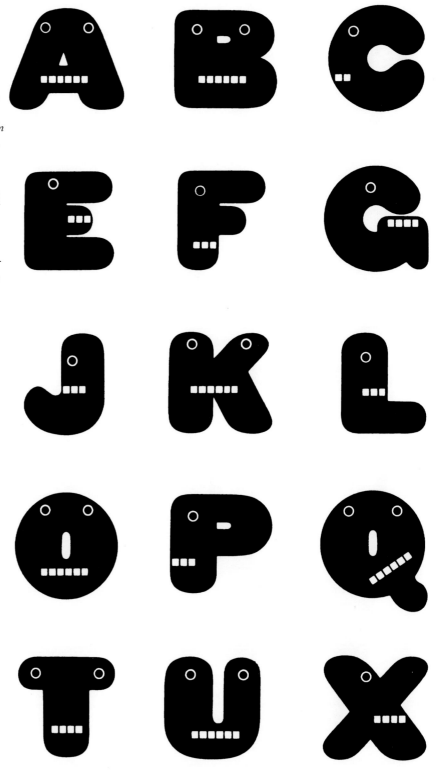

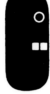

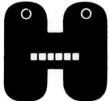
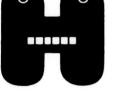
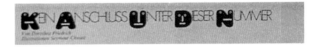

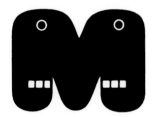
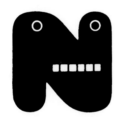

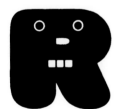
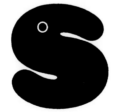

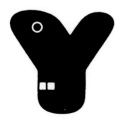
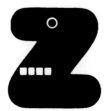
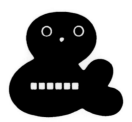

197.1

197.2

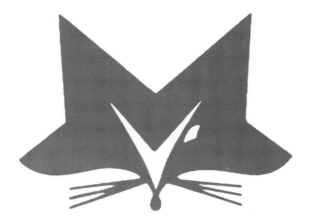

198.1

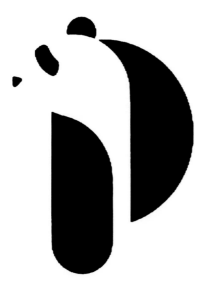

198.2

198.1
Designer: Jay Dixon
St: Dixon & Parcels Associates
1958 U.S.
Client: Moore Super Stores, Inc.
 Logo
 This fox TYPE*face,* uses the "M" shape to create the face. The negative space becomes the snout. The logo implies that the shopper is smart as a fox, to shop at these stores.
Principle Type: Handlettered

198.2
Designer: Michael Domer
1993 U.S.
Client: Panda Group
 Promotional logo for a paper manufacturer
 The negative space of the "P" becomes a TYPE*face.* The bowl of the "P" becomes the body and the stem a leg.
Principle Type: Handlettered

199.1 199.2 199.3 199.4
Designer: Craig Frazier
ST: Frazier Design
1991 U.S.
Client: Design Realization
 Children's book illustrations
 The "B" for bear, The "Y" for yak, "T" for tiger and "Z" for zebra become TYPE*faces.* These illustrations were created to provide letter recognition to children aged three and older, as well as visualization skills, knowledge of animals and just plain fun.
Principle Type: Handlettered

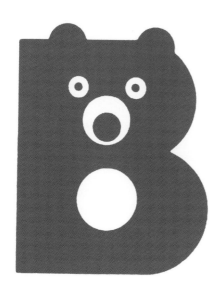

199.1

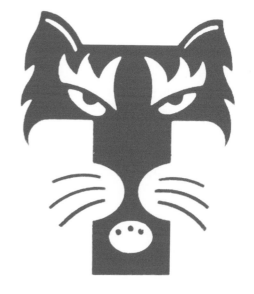

199.2

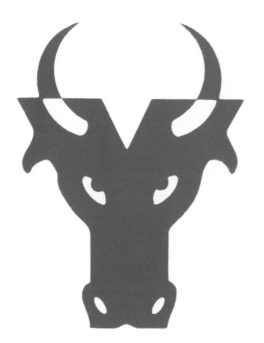

199.3

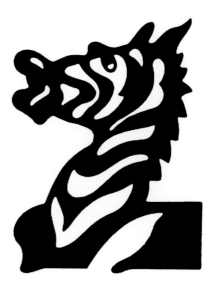

199.4

200.1
Designer: Craig Frazier
ST: Frazier Design
1991 U.S.
Client: Design Realization
 Children's book illustrations
 The "R" for raccoon is another in the
 series of "Alphabet Critters" TYPE*faces.*
 The block "R" with the addition of tail and
 ears becomes a simplified animal, the nega-
 tive space of the bowl defines the features.
Principle Type: Handlettered

200.2
Designer: George Giusti
1964 U.S.
Client: Penguin Books
 Logo
 This mark for books published by Penguin
 incorporates the "A" for architecture and art,
 the subjects of this series, and a simplified
 penguin illustration.
Principle Type: Handlettered

201.1
Designer: Antonio Manoli
1936 Canada
Client: Williams Canning Company
 Logo for a fish canning factory
 A simple circle with a "W" and two
 circles for eyes define this walrus TYPE*face.*
Principle Type: Handlettered

201.2
Designer: Chun-wo Pat
1988 U.S.
Client: Part of a student project
at Cooper-Union
 Word illustration
 The raccoon becomes a TYPE*face* when
 the double "O" is reversed from a black
 rectangle. This is an example of combining
 the pictorial qualities of Chinese calligraphy
 in an English word.
Principle Type: Futura

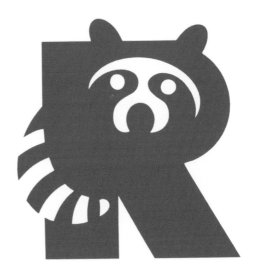

200.1

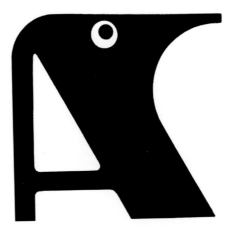

200.2

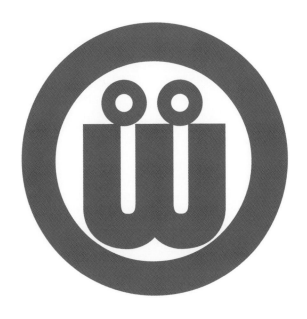

201.1

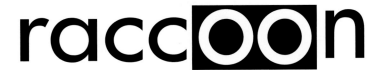

201.2

202.1
Designer: Karl Schulpig
1923 Germany
Client: Milchwerke, Inc.
 Logo for a dairy
 The "M" is the basis for this TYPE*face*. The addition
 of ears and a snout complete this cow symbol.
Principle Type: Handlettered

202.2
Designer: Walter Kersting
1924 Germany
Client: Molkerei Zentral Oldenburg
 Logo for a dairy
 This TYPE*face* combines the initials "M, Z & O"
 to create another version of a cow face. There is a
 strong cartoon personality in this mark.
Principle Type: Handlettered

203.1
Designer: Anonymous
1987 U.S.
Client: University of Texas, Austin
 University logo
 This illustrative TYPE*face*, the Texas steer, has a
 "U" face and the "T" crossbar as horns.
Principle Type: Handlettered

203.2
Designer: Florent Garnier
1988 France
Client: Le Toro Cie.
 Logo for a clothing manufacturer
 The "T" provides the basic structure of this
 bull TYPE*face*. The triangles and horn shapes
 resolve the face.
Principle Type: Handlettered

203.3
Designer: Borut Vild
1990 Yugoslavia
Client: Taurus
 Logo for a trading company
 This italic TYPE*face* uses the same elements as the
 two above with quite different results.
Principle Type: Handlettered

203.4
Designer: Richard Foy/ Communication Arts
1989 U.S.
Client: Amador Land & Cattle Co.
 Logo for a residential community
 This TYPE*face*, with its roots in the brand marks of
the nineteenth century, is an inverted "A".
Principle Type: Handlettered

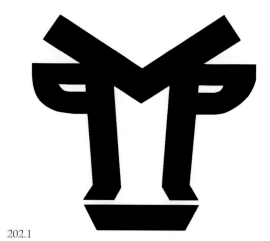

202.1

202.2

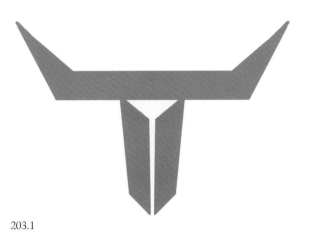

203.1

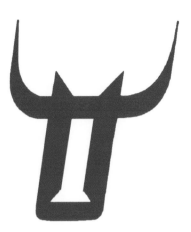

203.3

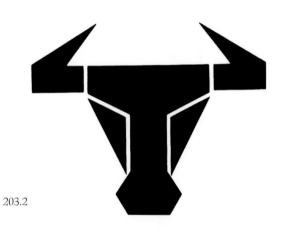

203.2

203.4

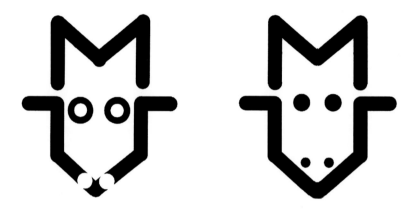

204.1

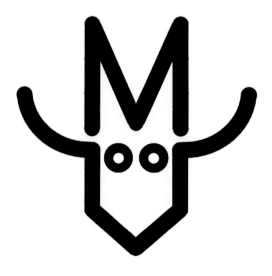

204.2

204.3

204.4

204.1
Designer: Shigeo Katsuoka
1981 Japan
Client: Monde Restaurant
 Logo for a steak house in Tokyo
 The slab serif "M" becomes a cow. The
 addition of horns and dots for eyes complete
 this TYPE*face*.
Principle Type: Stymie Bold/handlettered

204.2 204.3 204.4
Designer: Gerry Rosentswieg
St: The Graphics Studio
1986 U.S.
Client: Kirk Paper Company
 Studies for an illustration
 These TYPE*faces*, illustrating the word "Moo",
 are made from the "M" as ears and the double
 "oo" as eyes.
Principle Type: Handlettered

205.1
Designer: Felix Beltran
1987 Mexico
Client: Vaqueria Victoria
 Logo for a cattle ranch
 The triangular "V" becomes the face
 of a steer, the addition of an arc completes
 the TYPE*face*.
Principle Type: Handlettered

205.2
Designer: Kunihiko Sato
1990 Japan
Client: Senmaya-chomin Conference
 Symbol for a planned community
 The "S" becomes a dark horse, the
 negative lower space becomes a second
 face in this TYPE*face*.
Principle Type: Handlettered

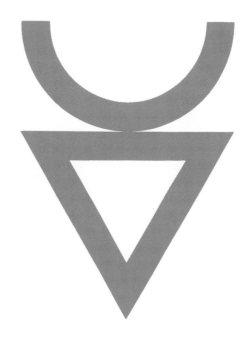

205.1

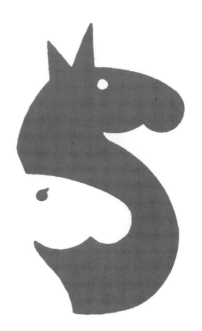

205.2

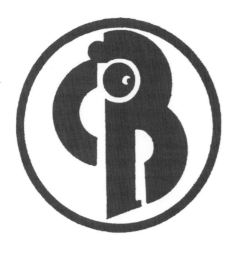

206.1

206.1
Designer: Maurice Demolein
1933 France
Client: ComBustibles
 Logo for heating materials
The combination of "C" and "B" becomes an
elephant. This machine age TYPE*face* owes much
of its charm to the technical rendering style
of the artist.
Principle Type: Handlettered

207.1
Designer: Terry Lamb
AD: Mike Salisbury
ST: Salisbury Communications
1990 U.S.
Client: The New United Artists
 Logo for a film studio
This TYPE*face*, a "U" and "A", drawn to become
an elephant has a great deal of charm. The "U"
is an ear, the crossbar of the "A" is the elephants
tusk, and the vertical counter is the trunk.
Principle Type: Handlettered

207.2
Designer: Shiro Ohtaka
1987 Japan
Client: Universal - Japan
 Proposed logo for Universal Safari
The simple "U" and two rectangles become the
face of an elephant, in this elegant TYPE*face*.
Principle Type: Handlettered

207.3
Designer: Karl Schulpig
1923 Germany
Client: Radium Gummiwerke
 Logo for a rubber producing company
The "R" with a little invention becomes an
elephant. The bowl of the letter redrawn as
a circle becomes the face shape. The leg of the
"R" becomes the trunk, and the tail acts as a
tusk. Two dots, as eyes, complete the TYPE*face*.
Principle Type: Handlettered

207.1

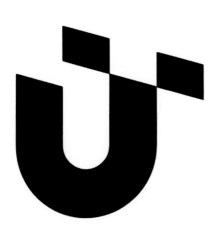

207.2

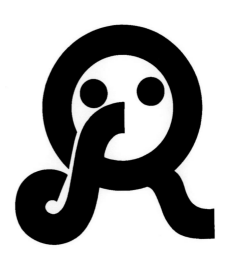

207.3

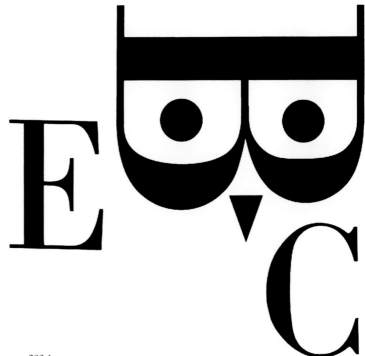

208.1

208.2

208.1
Designer: Walter Allner
1989 U.S.
Client: Educational Broadcasting Corporation
Logo for television network
The wise old owl is created from a "B" which has been rotated 90 degrees. The resulting TYPE*face* becomes eyes and horns of an owl. The "E" and "C" become wings.
Principle Type: Handlettered

208.2
Designer: Scott Feaster
1992 U.S.
Client: Cobb Hatchery
Logo for a chicken farm
This TYPE*face*, a chick and an egg, created from an egg shaped "C". The simplicity of this symbol insures its recognition.
Principle Type: Handlettered

209.1
Designer: Tony Burghart
1956 Germany
Client: Tauber & Sohn
Logo for a publisher
The ampersand becomes the structure on which this TYPE*face* bird is designed.
Principle Type: Handlettered

209.1

210.1
Designer: Gan Hosoya
1976 Japan
Client: Mitsui Forest
　Logo for a real estate developer
　This "M" TYPE*face* shows a rare economy, the
casual character of the letter becomes face shape
and beak. The addition of two dots as eyes
completes this symbol..
Principle Type: Handlettered

210.2
Designer: John Heartfield (Hans Herzfeld)
1919 Germany
Client: Malik Verlag
　Pictogram logo for a publisher
　This TYPE*face* is a spelled out pictogram of a bird.
The san serif letters "M, A, L, I, K" are combined
to create this chick like beast. The dark circle shape
unifies the image, and gives the mark substance.
Principle Type: Handlettered

211.1
Designer: Walter D'Hollander
1984 Belgium
Client: Christiensen Toys
　Logo for a toy manufacturer
　This simple "C", with two dots for an eye and
two dots for the wheels of a pulltoy, has a strong
recognition value. The "C" is a vaguely
toucan-like TYPE*face*.
Principle Type: Handlettered

211.2
Designer: Hiroshi Ohchi
1972 Japan
Client: Japan Games and Toys Company, Ltd.
　Logo for a toy manufacturer
　The "G" with a little invention becomes the
head of this bird. The "J" is the body and tail
feathers of this TYPE*face.*
Principle Type: Handlettered

211.3
Designer: Shigo Yamaguchi/Masaki Furuta
1983 Japan
Client: Early Bird Company, Ltd.
　Logo for a food distributor
　This "E" becomes the head of a bird. This
TYPE*face* embodies the concept of speed by
the style in which it is drawn.
Principle Type: Handlettered

210.1

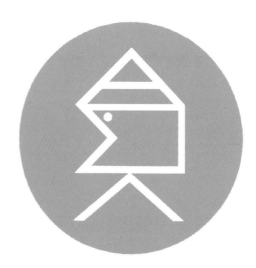

210.2

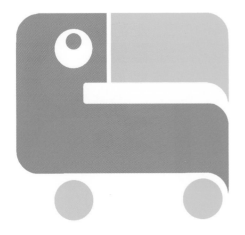

211.1

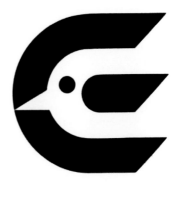

211.3

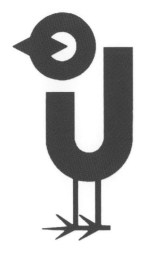

211.2

212.1
Designer: Szekeres Istvain
1985 Hungary
Client: Baromfifeldolgozo
 Logo for poultry packaging company
 The "B" becomes a chicken's head, this spare
 TYPE*face,* with a minimum of type modification,
 creates a strong logo.
Principle Type: Handlettered

212.2
Designer: Dick Cady
1973 U.S.
Client: Rhode Island Reds
 Logo for a professional hockey team
 The casual drawing of the "R", permits the
 tail of the letter to become a roosters wattles.
 The negative space in the bowl is the eye of
 this TYPE*face.* The addition of a beak and
 cockscomb complete the symbol.
Principle Type: Handlettered

213.1
Designer: James Potocki
ST: John Follis and Associates
1973 U.S.
Client: Republic Air Conditioning
 Logo for an air conditioning supplier
 This strong TYPE*face* logo, an eagle "R", designed
 with a certain amount of patriotic "jingoism" places
 the eagles face in the letters' negative space.
Principle Type: Handlettered

213.2
Designer: Marcello Minale
ST: Minale Tattersfield and Partners, Ltd.
1969 Great Britain
Client: Zambian Airways
 Logo for an airline
 The "Z" with the addition of feathers appears
 to be a soaring eagle. This TYPE*face* with the
 addition of a dot eye and curved beak become
 a very recognizable logo.
Principle Type: Handlettered

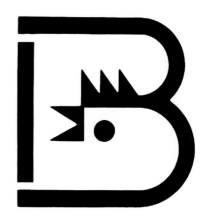

212.1

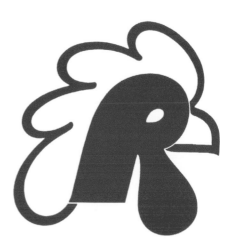

212.2

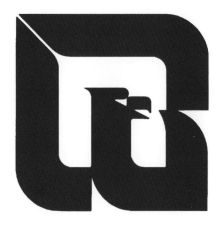

213.1

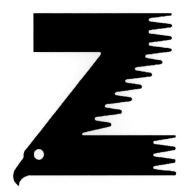

213.2

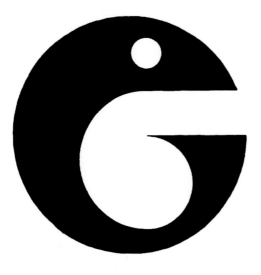

214.1

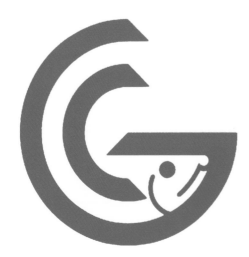

214.2

214.1
Designer: Jacques Richey
1978 Belgium
Client: Globus Conserveries
 Logo for a fish farm
The "G" becomes a fish. Simply drawn this TYPE*face* has an elegance, the crossbar is the tail. The addition of a white dot reversed from the head of the letter completes the mark.
Principle Type: Handlettered

214.2
Designer: Takashi Ishida/Waichi Ishikawa
1990 Japan
Client: Gifu Prefecture
 Promotional symbol for a tourist area
Another "G" fish TYPE*face*, with very different results.
Principle Type: Handlettered

215.1
Designer: J. Robert Faulkner
AD: Donald E. Smolan
1989 U.S.
Client: Colony Films
 Logo for a film producing company
The simple "C" fish, eating its own name makes a witty TYPE*face*. The triangle tail and the dot eye completes the mark.
Principle Type: Handlettered

215.2
Designer: Senior packaging class at
Art Center College of Design
1987 U.S.
Client: Norwegian Sardine Advisory Board
 Package design
The eye of the fish is the "O" in the brand name "NOR". This prototypical package does not have the boiler plate copy usually associated with packaging assignments.
Principle Type: Handlettered

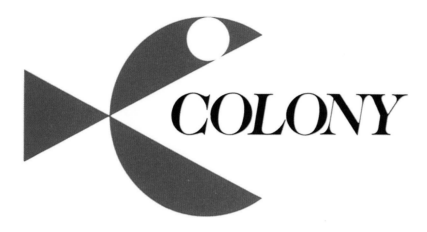

215.1

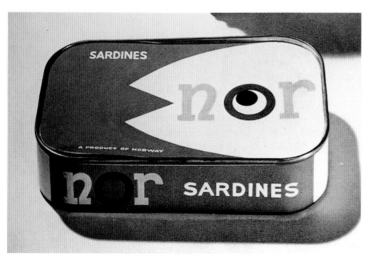

215.2

TYPE*faces*
DESIGNERS

TYPE_faces_
ART
DIRECTORS

TYPE*faces*
STUDIOS
OR AGENCIES

TYPE*faces*
CLIENTS

TYPE*faces*
CREDITS & THANKS

It is really quite amazing to come to the conclusion of a project like this - the research, the production and the follow-up all take a special kind of patience, my assistant, and friend Lisa Woodard provided most of it. I would also like to thank Anita Bennett and Rick Brian for their expertise and help, this project would have suffered without them. I also want to thank Jerry McConnell for his forbearance and continuing good spirits in the face of all the delays and excuses that make up publishing. G.R.

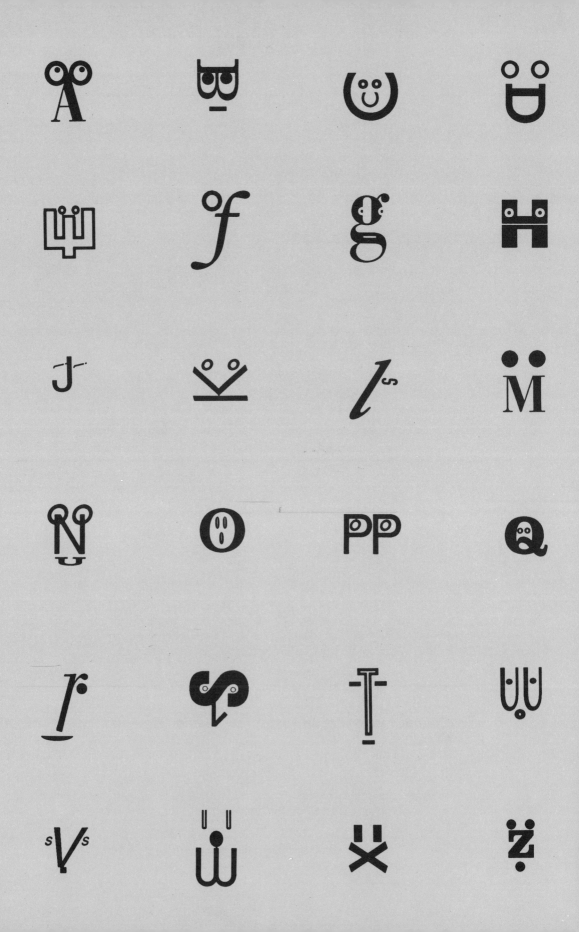